DAN OSTERMILLER

A Sculptor Of Animals

By Jim Eaton

ACTIAN PRESS
Loveland • Colorado

In Association with

FENN GALLERIES
Santa Fe • New Mexico

Gift

© 1990 by ACTIAN PRESS

Book and Cover Design by Molly Gough
Photography by Warren Blanc, The Image Maker and Fabrice Photography
Edited by Elaine Calabro

First Edition
1 2 3 4 5 6 7 8 9

ISBN: 0-9626881-0-X
LCCN: 90-082306

Printed on 100#White LOE Dull text, Dust Jacket on 100# White LOE Gloss text.
Library bound with Roxite "A" Linen cover material, using Multi Antique Thistle
end papers.

Printed in the United States of America by
Johnson Publishing Company, Inc.
1880 South 57th Court
Boulder, Colorado 80301

CONTENTS

SCULPTURES

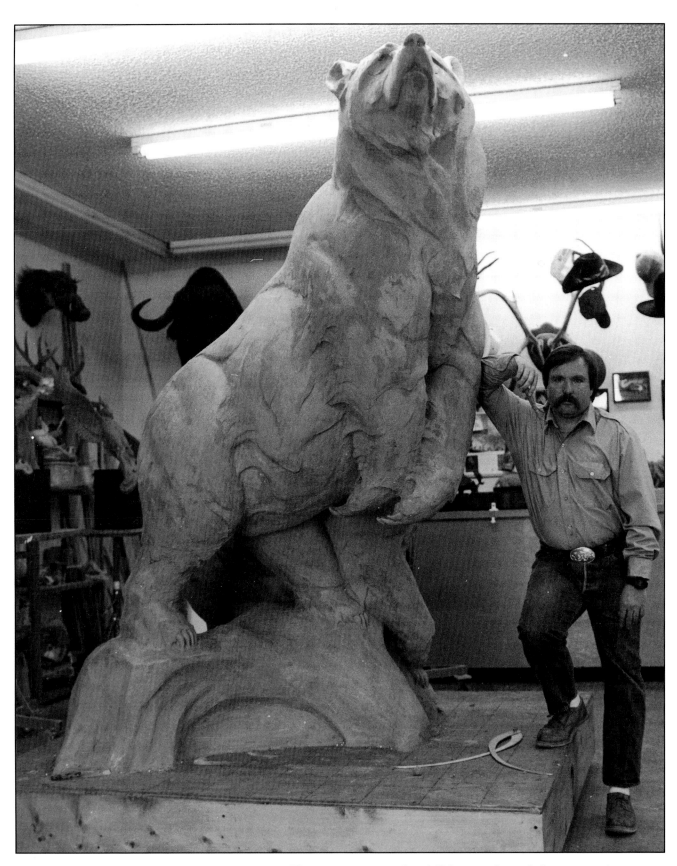

The two mountain grizzlies of "Mountain Comrades" tower over their creator.

FOREWORD

I t is a unique pleasure to discover a work of art that truly captures you for a moment. Its intense beauty, or perhaps the drama of the subject, calls for more than your attention. It speaks to your emotions and imagination. When I first experienced the work of Dan Ostermiller, I was captured.

To know Dan Ostermiller is to know his work. The opposite is true as well. Dan draws upon a lifetime of experience with the animal world. The compassion and understanding he feels for his subject is genuine. The attributes of his personality allow him an unusual freedom in his work with animals; Dan is open, friendly and trusting. His quiet nature and relaxed attitude put you at ease, and his sincerity is heartwarming. These qualities are apparent in his work and combine with a truly gifted talent—a talent which brings together masterful skill in representational sculpture, stylized technique, innovation and an invaluable understanding and awareness of his subject.

Dan's insightful interpretations are provocative and honest. His sculptures are natural, not contrived. They are as endearing and beautiful as they are powerful and spirited. The barriers and silence of their world is somehow broken, and Dan allows us an intimacy with the animal world that I've not experienced through any art form before.

Dan Ostermiller is at the forefront of American sculpture. It is a great privilege for me to share in this book about Dan Ostermiller, an artist who is, and whose work is genuine in every sense of the word. At the young age of 33, Dan is an established and an accomplished sculptor. The future of Dan Ostermiller holds a lifetime of creativity.

Fedra Matteucci

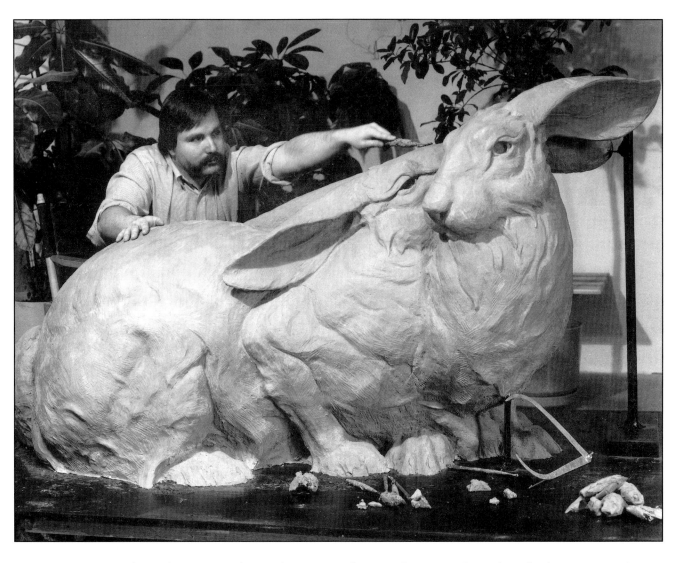

Monumental pieces have proven to be one of Dan's strengths as a sculptor. Here he works on his first monumental piece, "A Friend Indeed."

INTRODUCTION

"My ultimate goal as a sculptor is to create art that will be admired throughout time—to say things in my work that will continue to be said forever."

Dan Ostermiller

G oals and dreams are made of the same stuff. A goal of speaking to future generations through a visual medium like sculpture can be called a lofty goal or a big dream.

For at least the last three generations, the Ostermiller family has a good record of making dreams come true. Dan's grandfather, Pete Ostermiller, came to this country as an immigrant with a dream of owning his own farm. He accomplished that dream. Roy Ostermiller, Dan's father, dreamt of hunting animals all over the world. He too managed to live his dream. At the age of six, Dan Ostermiller dreamed of becoming a sculptor.

This book is a celebration of the realization of that dream.

Dan Ostermiller is a sculptor. More precisely, he is a sculptor of animals. His is not the most widely recognized name in the sculpting world today, but his work has been acclaimed by galleries and collectors alike. He is certainly one of the most important young sculptors on the American art scene today.

On July 2, 1956, Daniel Ray Ostermiller was born to Roy and Ruth Ostermiller, and to a tradition of craftsmanship that revolved around the world of animals. The Ostermillers

were co-owners of one of the largest taxidermy shops in the world, Frontier Taxidermy in Cheyenne, Wyoming. His father and a partner had built an international trade that brought a varied sampling of some of the world's wonderful and exotic animals through their doors. From day one, Dan had a front-row seat for an endless parade of animals—a seat he is yet to give up. His boyhood imagination was fired by what he was able to drink in from an environment filled with a rich mix of animals. He was able to see the wild and graceful patterns nature had embossed upon its creatures and to touch their textures that ranged from the craggy rough hide of an elephant to the deep soft fur of a fox. He learned of their lives and environments by reading the clues left in their hides.

The animals that were shaped into lifelike forms by the hands of Frontier's employees were enough in themselves to enflame Dan's love for the animals, but it was the stories from the hunters that gave them a quality that was larger than life. As much as mounting the animals, listening to the stretched tales of how each hide was acquired by the hunter was a part of his father's job. On Dan's impressionable ears fell the often exaggerated stories of safaris in Africa, tiger hunts in India, fishing trips off the coast of Mexico, and caribou hunts in Alaska. The animals grew to god-like proportions in Dan's mind as the hunters augmented their physical abilities and enhanced the animals' intelligence to make a better story.

Dan was the only boy of the three Ostermiller children. His gender alone was enough to make him the natural selection to carry on the family business one day—a male-dominated world that centered on hunting, fishing, and trapping. He enjoyed a close relationship with his father as he accompanied him on hunting trips and short business excursions.

It was on one of these many trips that Dan was struck by the inspiration to become a sculptor. His father visited the taxidermy shop of Lloyd Woodbury, an old friend and associate in Rawlins, Wyoming. Roy was there to pick up a set of taxidermy mannequins Woodbury had built for him. While the two men sank into adult conversation, Dan explored the

contents of the shop. His eyes strayed to some large plaster death casts Woodbury had made and hung high on the shop's white walls. He moved along guessing what each one had been until his eyes were caught by another figure. He moved closer to examine it. It was a small plaster statue of a deer that had sat long neglected upon of one of Woodbury's shelves. Then he found others scattered about the shop: a bear, an antelope, a horse. These were plaster castings Woodbury had made as a boy while growing up on a ranch in northwestern Wyoming. They were crude little figures, but they fascinated young Dan nonetheless. The years of settling dust enhanced the texture of their yellowing surfaces which made them all the more interesting to the boy.

"Looking back, it makes me a believer in destiny. It was like I was supposed to see those sculptures and feel the excitement I felt then," Dan said. "When I saw those plaster animals, I was nearly hypnotized with fascination. I knew from that day on that I wanted to spend my life creating animals just like the ones that sat in front of me that day."

It's a lucky man who finds his dream at a young age. Once the dream is decided upon, a path automatically materializes leading from where the individual stands at that time and ending at the foot of the final goal. The path may be filled with obstacles, detours, and distractions, but it is complete from start to finish. Its boundaries and requirements are defined and the individual's attention, efforts, and energy can all be focused in a definite direction for as long as the dream is held. All the person has to do is get on that path and stay on it. However, when the path is one of creative endeavor, it's often a long dark journey lit only by the glow of imagination and effort. As Dan would find out, staying on the path he had selected required unrelenting determination that often made life difficult for himself and those close to him.

His first efforts were pencil drawings he

scratched out on scraps of paper and the pinched clay figures he made as a child at his father's work bench. His talent was recognized and nurtured throughout his boyhood and early adolescence. As he grew and his artistic talent blossomed, Dan developed an aversion to regimented academic art and decided school was not the vehicle to move him closer to his dream. His school was his father's taxidermy shop. There he learned the craft of taxidermy, but he learned it with the hopes of one taking that knowledge much further than the confines of skins and mannequins. From his years as a taxidermist, he built a rich knowledge of anatomy from which he continues to draw for the technical aspects of his work.

When he was young, Roy had rejected his father's plans to make him a farmer and chose his own life as a hunter and taxidermist. In much the same way, Dan thwarted his father's plans for him to become a taxidermist to follow the path of a sculptor. From the day he cast his first piece, a simple ram's skull in bronze, his direction was set.

Dan has never lost the boyhood enthusiasm he used to absorb the world of animals and hunting. With this excitement and zeal, he continues to approach his work as an animal sculptor, as well as everything else he enjoys in life. The knowledge of the animals he sculpts combined with the abiding respect he has always had for them comes through to state clearly , "This is a Dan Ostermiller piece."

Some may say it is too early to present a book about an artist who is so young and only beginning to realize the promise of the career before him. This book should serve as an introductory statement or the first volume in a series of books covering what promises to be a long, prolific, and distinguished career that will certainly influence the world of sculpture. It is an attempt to cover the nebular period of his life, leaving ample room to expand and revise his theories in future editions covering his life and art.

CHAPTER 1

Like Father Like Son

There are two maxims about fathers that pertain directly to the relationship Dan and Roy Ostermiller enjoyed. The first: To know the man, you must first know the father.

To begin the story of Dan Ostermiller's life, it is fitting to step back a few generations and examine the development of the major influence in his life—his father. It is undeniable that Roy Ostermiller was the greatest influence on Dan and his career. Everyone born to this world has choices in relation to where he is going in his lifetime. However, it's the decisions made by the parents that determine the point from which the individual departs on life's journey. To see the point of origin for Dan's journey to his destination as an animal sculptor, a look at his father's life will shed some light on the environment that nurtured this artistic talent.

The lesson contained in the second aphorism is learned only one way—the hard way. After Roy's death in 1988, Dan's good friend and fellow sculptor Fritz White told him, "You do not truly become a man until your father dies." It has proven itself true. The circumstances that took his father from Dan's life were as unavoidable as they were unfortunate. Suddenly, the powerful force that he had learned from, had fought with, and had loved was removed forever. No longer would that strong figure be hovering over him in every thought. In Roy's absence, Dan learned to live without that source of strength a father's presence provides. The harder choices in life became solely his.

Roy was the son of German-Russian immigrants who came to Colorado to work the beet harvests. These people

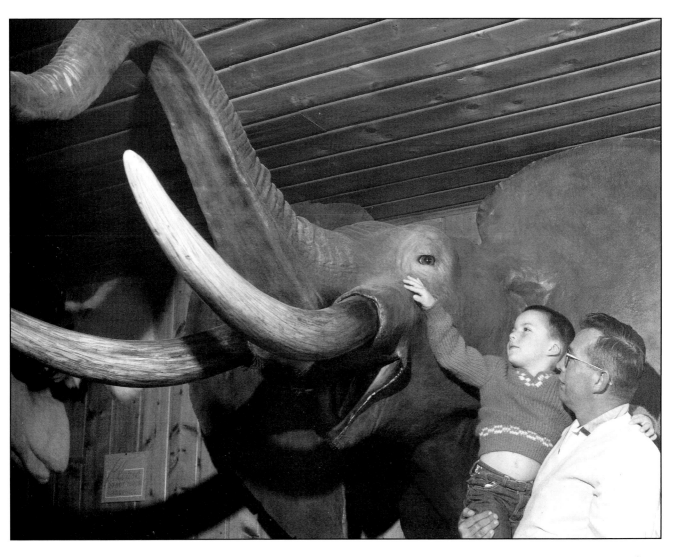

Childhood around Frontier Taxidermy was a hands-on experience. Roy holds 5-year-old Dan for a photo to accompany a newspaper article written about Roy and his work.

were industrious laborers who saved to buy the farms where they had served as hired "stoop" laborers. Pete Ostermiller purchased an 80-acre farm outside Berthoud, Colorado. Here, he and his wife Margaret raised three boys and seven girls. Roy was the adventurous one who started his legacy of hunting with a pet ferret he used to kill rabbits on the farm. After the gift of a rifle from his father when he was 16, his desire to hunt swept him away from the farm life forever. He hunted the mule deer, mountain lions, and an occasional bear in the foothills a few miles to the west. He was eventually drawn to the high country where the larger deer and elk were to be found.

There was no turning him back once he tasted the thrill of the hunt. Roy announced to his family that someday he would travel the world to hunt animals. They humored him, but it wasn't likely a farm boy from Berthoud would ever see elephants, lions, tigers, and the more exotic breeds that roamed lands half way around the world.

In 1949, Roy met and married Ruth Ann Anspauch. The young couple moved to Loveland, which lies seven miles north of Berthoud. Roy was working at a meat packing plant on the southern edge of town and began dabbling in taxidermy, as Ruth recalled, "with a man named Jones on East Tenth Street," which, ironically, is just a few blocks from Dan's present studio.

Roy's photos and stories of Africa fired Dan's desire to see and hunt the exotic land since childhood.

Joe Nevins, Roy's partner from 1954 until his death, recalled that Roy had told him he had shot a couple of owls and had taken them to the Loveland shop and asked to have them mounted. The proprietor said he didn't have time, but Roy was welcome to use the shop to mount them himself. These owls were the first step in a long journey that would take him around the world in pursuit of animals.

In 1952, Ruth and Roy

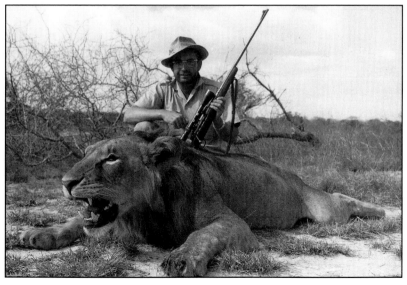

moved to Cheyenne where Roy worked for the railroad for two years before being laid off. In those two years, Roy continued hunting and mounting the local animals.

"The first time I met Roy was in the fall of 1952," Joe recalled. "He brought a couple of antelope that he had killed over to my shop and said I could have them if I could use them. We talked a bit and he said he had been mounting a few things in his spare time and would eventually like to get into (taxidermy) full time. It wasn't too much later that my partner mentioned he wanted out and I started thinking, 'Hey, who was that guy that came in here?'"

Joe tracked him down and Roy bought out the partner for $500.

"Roy's dad had a fit," Ruth said. "He thought the only living in the world was farming and that we'd surely starve to death. He thought the only thing a taxidermist did was put heads on the walls."

Ostermiller tradition prevailed; it was necessary for the son to prove his father wrong. From its meager beginnings, Frontier Taxidermy would grow to become one of the largest taxidermy shops in the world.

During these years of Frontier's early growth, Daniel Ray Ostermiller was born on July 2, 1956. Sandwiched between two sisters—Robin Lynn, four years his senior, and Jennifer, 12 years behind him—Dan was the only male child of the family. His sisters were not discriminated against because of their gender, but his sex favorably opened the doors to his father's business.

Frontier Taxidermy was his second home. "He was over at the shop from the time he was born," his mother said. "I worked in the office and took him with me. He literally grew up there."

His childhood playground was among the legs of the tolerant men going about their work. There were large chilly rooms filled with salted hides, another with racks of antlers, and still others filled with animals in various stages of being mounted. They were all there for a curious boy to explore. Joe

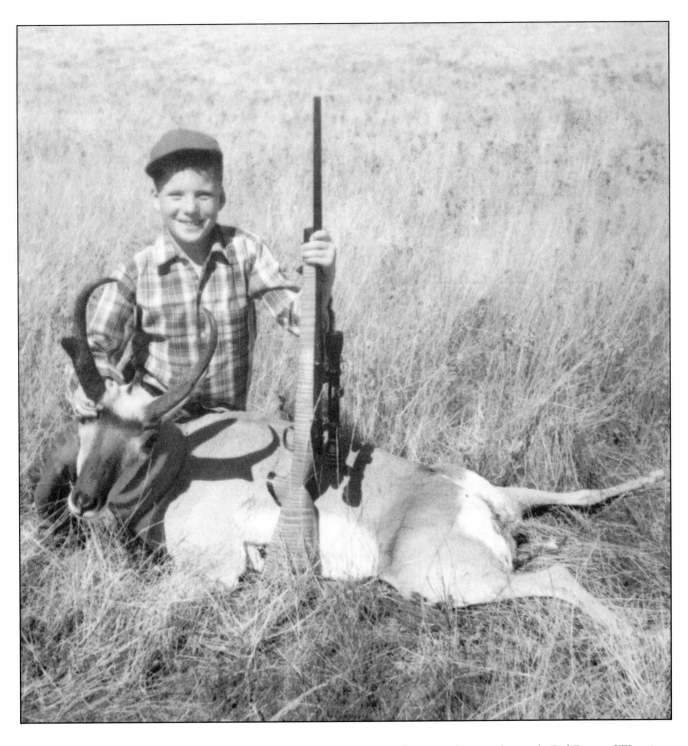

Dan began hunting big game at the age of 9. Here he poses with his first trophy, a pronghorn antelope in the Red Desert of Wyoming.

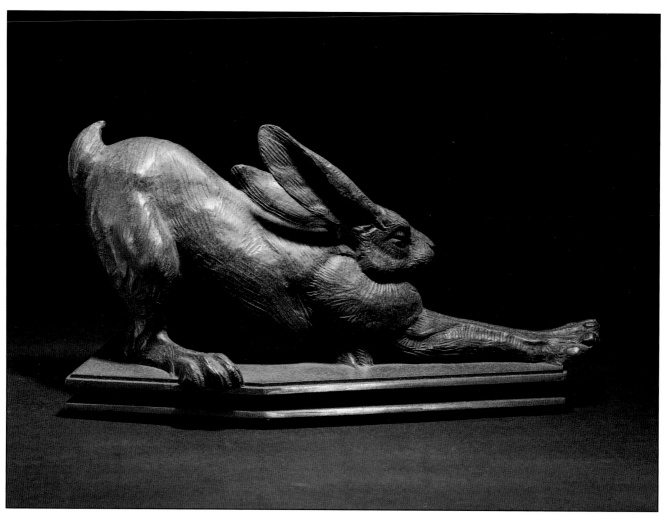

Stretch, 12" x 5", Edition: 30

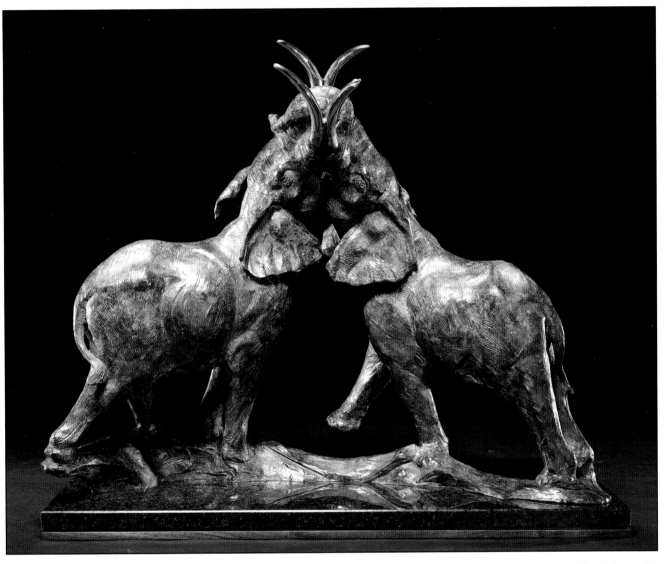

Savannah Dispute, 27" x 22 ¹/₂", Edition: 20

remembers Dan digging in the shop's clay barrel to make figures at his dad's work bench. They were nothing special, just lumpy awkward figures "like any kid would make."

It seemed the kid couldn't grow up fast enough to be included in his father's hunting excursions. Some of Dan's earliest memories are of a sleepy-eyed boy who couldn't put enough clothes on to stay warm as he headed for a sit in a chilly duck blind, or to bump across a windy Wyoming plain in pursuit of antelope, or to pack into the hills to hunt deer and elk. It was not a force-feeding of Roy's world; more like a big meal for a small appetite.

"Dan and his dad started fishing and camping when he was really small," his mother remembered. "There were always fishing and hunting, and backpacking trips. I have a home movie of them heading for a trip when Danny was tiny and he was wearing the pack frame Roy had made him out of little wooden dowels."

Dan was only 9 when he shot his first big game—a pronghorn antelope. After that, he had the hunting fever.

"He shot his first elk when he was 11. Roy and I were with Danny while we were spotting an elk across the meadow. There was a man there that asked Danny if he wanted him to shoot his elk for him. His dad turned around and snapped at him: 'No you won't shoot his elk. The boy will shoot his own damned elk.'"

As Danny grew, so did his father's business. In 1960, two

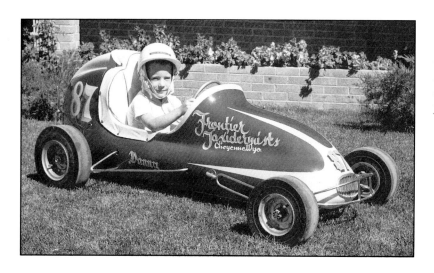

Racing cars was one of the many interesting challenges Roy Ostermiller dreamed up for his son.

Frontier clients went to Africa on an extended safari and sent the hides of their trophies back to Cheyenne for mounting. The skins were in horrible condition when they arrived, which proved to be a boon for Frontier Taxidermy. Roy and Joe discussed the possibility of going to Africa to hunt and to set up a station that would treat the hides taken by hunters and prepare them for shipment to their shop in Cheyenne. Joe took off for Mozambique, meeting with guides and hunters to persuade them to direct their taxidermy business to Frontier. Joe set up a dipping station to be run by an old friend from the States who would also train Africans to prepare the hides for shipment.

Joe was hardly unpacked from his African trip when Roy took off for his turn at hunting the animals of the African bush. This fulfilled the promise he had made to his brothers and sisters that he would someday travel the world to hunt big game. Roy and four clients spent two months in Somalia and India—two countries that had just recently opened to foreign hunters. This was a trip that would have lasting influence on young Dan.

"When Roy went hunting, he did more than hunt," Ruth said. "He took a movie camera with him everywhere he went. Roy took pictures of the natives, their homes, how they prepared their meals."

These flickering 16mm home movies, coupled with Roy's accounts of hunts and life in far away places, opened the eyes of a young boy to a world beyond the Wyoming plains. There was a whole world filled with animals and adventures that Dan had to see. He decided then that he too would someday experience Africa. Roy and Joe took turns escorting clients on safari. One minded the store while the other was off—in a very loose sense of the word—working. As hunters, they were both thrilled with the opportunity; as businessmen, they were pleased to receive the large amount of work their contacts pushed their way. Mainly from the African trade, Frontier grew to be one of the world's largest taxidermy shops.

The amount of energy Roy expended on his business

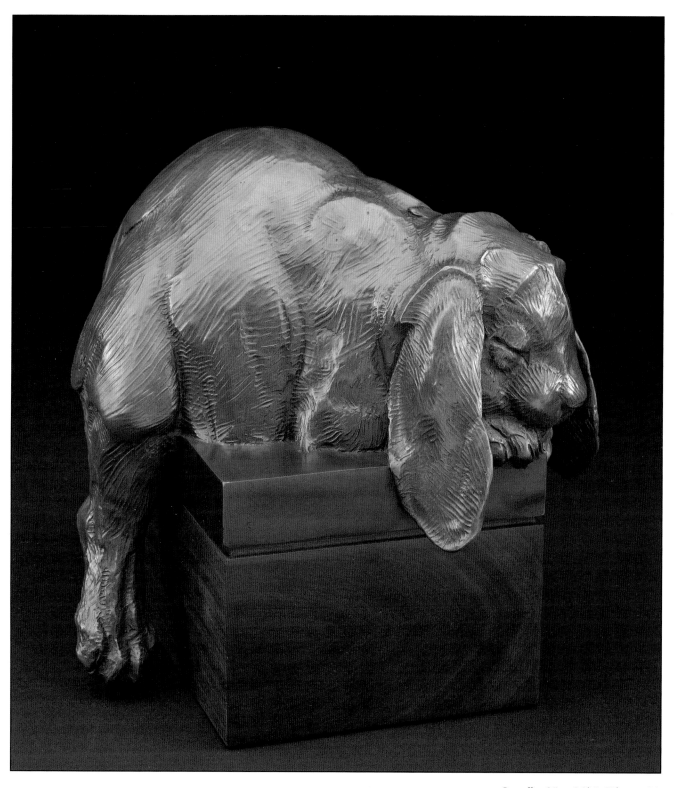

Camille, 8" x 9 ¹/₂", Edition: 30

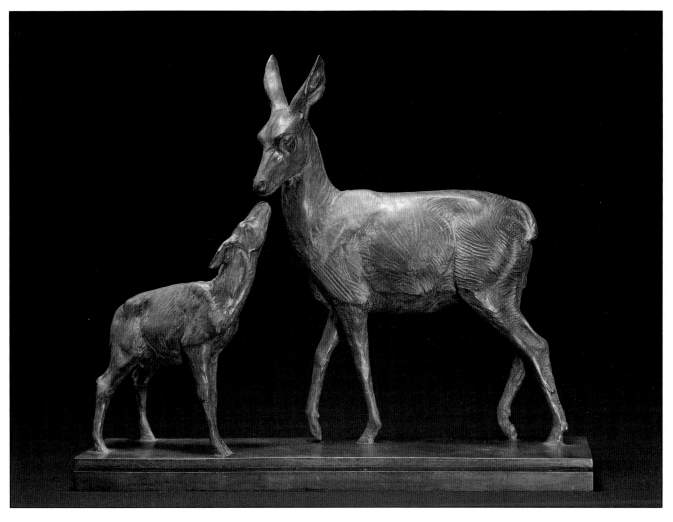

The Bonding, 12" x 7", Edition: 20

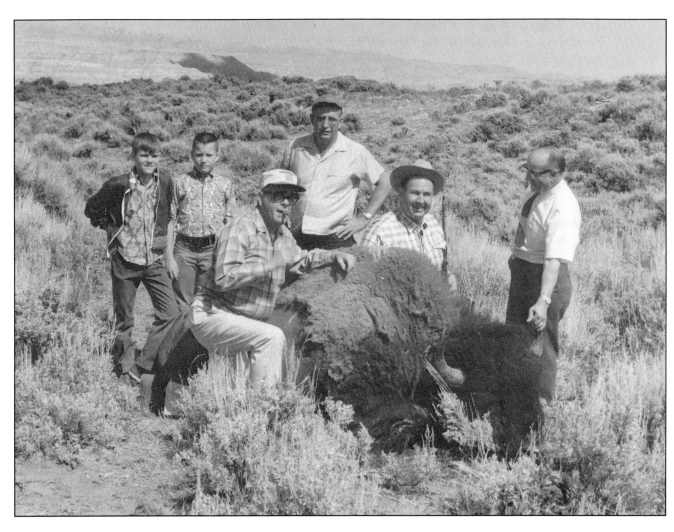

*Dan and a friend tag along with Roy (middle) on a buffalo hunt to DuBois, Wyoming,
where Governor Stan Hathaway (with gun) collected his trophy.*

would have consumed the average man, but he was a man in love with life and could seemingly go a dozen different directions at the same time and love every second of it. Despite his hectic life and the month-long absences, he always found time to enjoy his family. He made Dan's life one that for most boys is only a dream, filled with hunting and fishing trips, camping in the wilds, and whatever Roy could dream up—like racing cars.

Roy seemed to live vicariously through his son, doing the things that he wanted to do but never got the chance when he was a boy. One of the adventures he dreamed up for Dan included driving a candy-apple red midget race car sponsored by Frontier Taxidermy.

"When I was 6, Dad decided he needed a son that was a race-car driver," Dan said. "My racing days ended when I put that little racer right into a telephone pole."

Fritz White had the opportunity to get to know Roy and Dan together. "Roy and Danny had a very mature relationship. It was more man-to-man than father-to-son," Fritz said. "Roy was into all kinds of nutty things like playing in a hillbilly band, dabbling in different business ventures . . . whatever he could find that interested him. He made Danny part of that world. Roy had Dan racing midget cars when he was a kid and took him hunting and fishing. It all played heavily in the development of the child. When Dan was faced with all of these things, he had to react, which made him mature more rapidly."

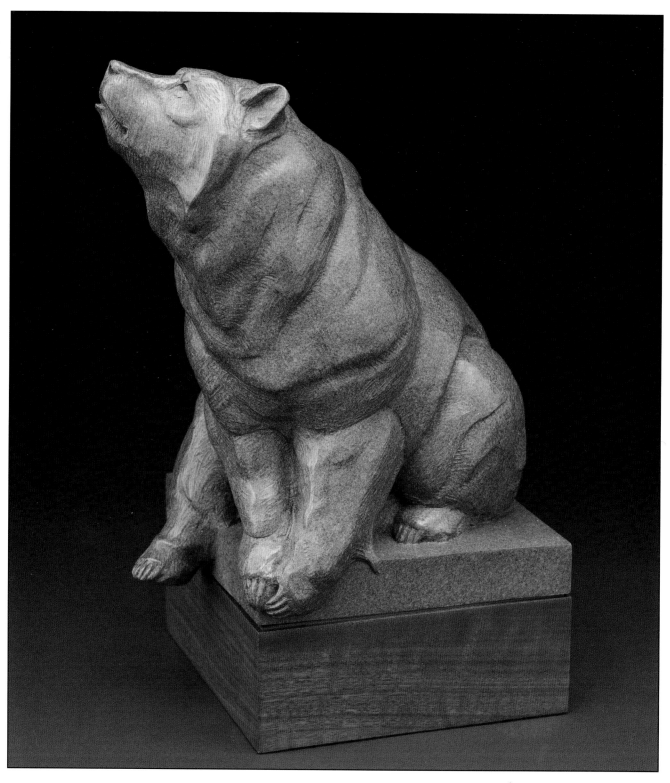

Panzón, 14 ¹/₂" x 9 ¹/₂", Edition: 20

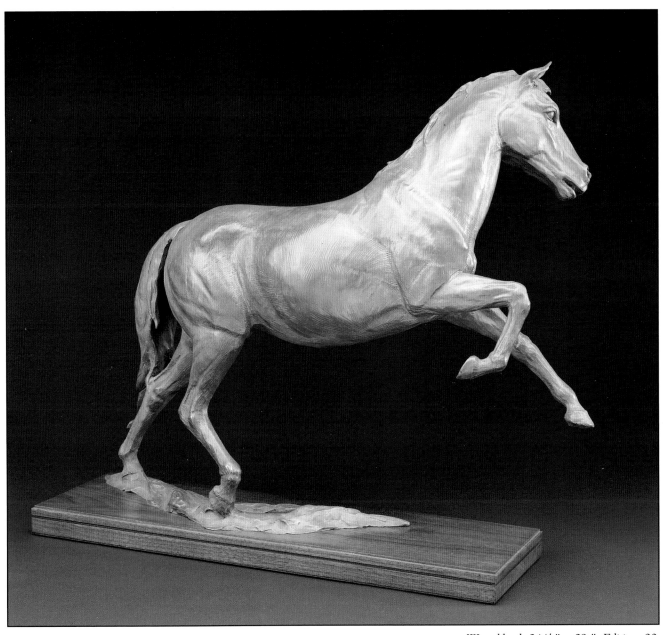

Warmblood, 24 ¹/₂″ x 29 ″, Edition: 20

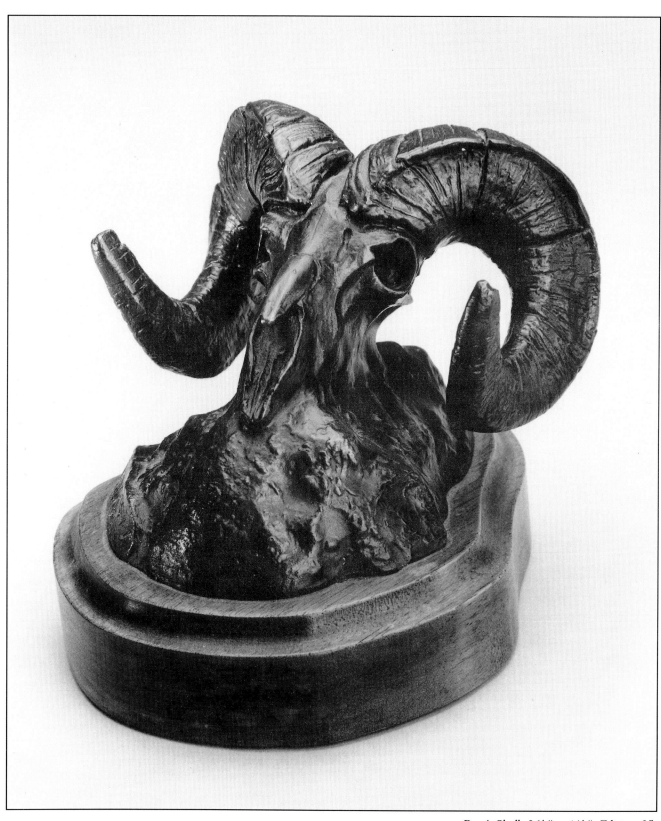

Ram's Skull, 3 ³/₄″ x 4 ¹/₂″, Edition: 25

Chapter II

The Teen Years: Taxidermy and Talent

The sight of some small plaster animals started something spinning within the boy's breast. It was a restless, constant movement that would pull him along the path he had chosen with the decision to make art his highest objective.

Dan's mother and older sister say the pictures he scratched out before he was old enough to attend school showed talent and promise. He was no prodigy, but he was a diligent worker. By his early teens he was bringing home ribbons from the fairs and school art shows in which he had entered his work.

To be an artist, as Dan had envisioned it, was to be mysterious and enigmatic. He dabbled in surrealism with the idea that he would be the next Salvador Dali. It was a sign of rebellion to produce these strange pictures filled with eerie figures, such as eyes peering from the darkness behind peeling wallpaper. This teenage rebelliousness also found expression in his defiance towards the art teachers who dictated what he was to create.

"One of his worst problems," his mother recalled, "was he fought with most art teachers because he felt they should always let the students be creative. They always told them what they had to draw, what they had to paint. He hated it. He thought the students should be allowed to be more creative and paint and draw whatever they wanted and how they wanted it—not how someone else wanted it. There were very few art teachers that would do that. Danny's the type that you don't tell him he has to do anything."

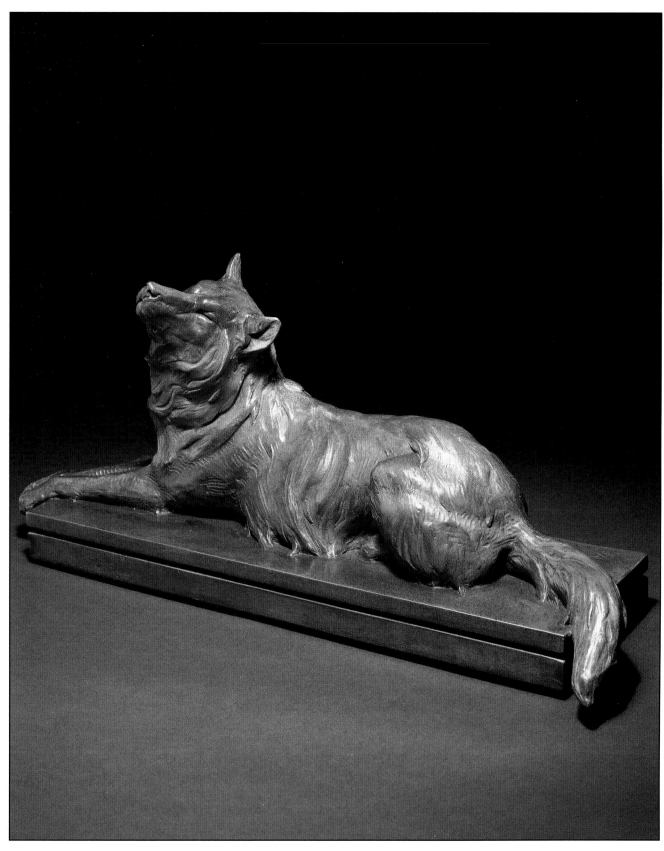

Arctic Sun, 7" x 16", Edition: 20

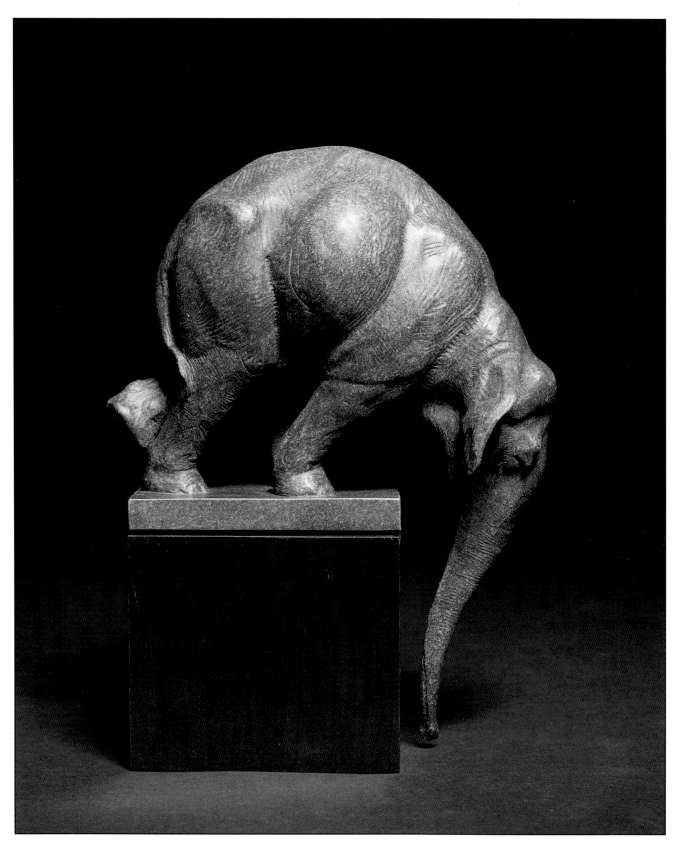

High and Dry, 12¹/₂" x 9¹/₂", Edition: 20

In his teens, art was a hobby, but his life was still directly tied to taxidermy. At the age of 10, he had begun mounting some of the animals he shot on weekend forays into the hills. When he was 14 he joined the crew at Frontier as a paid employee. He was now a professional and his father demanded the same quality of craftsmanship from his son as he did his other employees. He applied himself and honed his skills to a level that met his father's demands of perfection. Perhaps it was talent; perhaps he naturally absorbed the details of the work from his environment; perhaps it was just application and hard work. Most likely it was a combination of all three, but Dan was now accepted as a fellow craftsmen by the other Frontier employees.

The art of taxidermy goes much deeper than the notion Dan's grandfather had of it being a profession that only mounted heads on walls. It's a challenge of taking a skin from a once-living animal and giving it back the characteristics its species displayed in life. Taxidermy is almost a re-animation of animal flesh—freezing it in the middle of repose or action and making it believable.

It is craftsmen like Roy and Joe to whom hunters bring the skins of their prized trophies to mount or preserve in some fashion. The hunter describes to the craftsman the pose he wishes to see in the finished piece. The hide is then salted to preserve the skin and sent to a tannery for cleaning and tanning. When it returns, the taxidermist selects stock molds for the type of animals that will yield a mannequin on which the skin will be mounted. Wheat paste is applied to a resin paper and hand-placed in the mold and built to the desired thickness. A special pose may require the creation of a new mannequin. The taxidermist must then sculpt a new form from clay and cast it in plaster. If the animal being mounted has antlers, they are attached to the mannequin before the skin is applied. The skin is then stretched over the mannequin and features such as eyes, nose, and tongue are worked into the figure as it progresses.

As an impressionable teenager, Dan had his hands on many of these animals and was faced with the challenge of

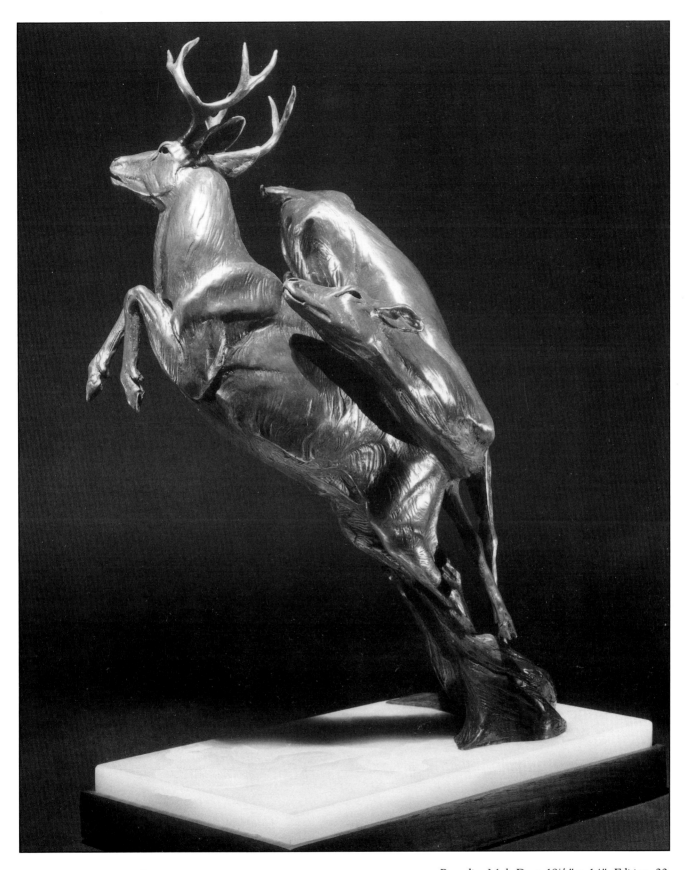

Bounding Mule Deer, 19¹/₂" x 14", Edition: 20

recreating a lifeless skin into a seemingly live animal. The task demanded attention to detail, a sense of proportion and balance, and a deep knowledge of the animal, its habits and habitat. As early as age 12, Dan began compiling reference material on the animals that appealed to him. He clipped pictures from magazines, took photographs, and made sketches. The material showed him how an animal holds itself as it walks, runs, and stalks prey. It gave insight to the direct influence of the environment on the nature of the species itself. As he handled the hides he learned the intrinsic differences between the animals from different parts of the world.

"The African animals are sleek, with a thinner coat that more readily shows the sinews, muscles and bone structure," Dan said. "They are also much more diverse—ranging from the delicate impala to the hulking giants like the elephant."

As Frontier's reputation and scope grew, Roy continually kept on the lookout for ways to expand and build the business. As the business grew, so did Dan's involvement and responsibility with the company. Roy and Joe came up with the idea of mass producing some of the more popular mannequin forms to sell to other taxidermists. Dan was handed the responsibility, which he handled adroitly, of compiling and creating the catalog to market the forms.

Dan was being brought into the fold and being groomed as the successor to the family business. The young man had other ideas though. The desire to be a sculptor still burned within him and he wore two hats: a taxidermist who mounted animals and an anatomist who wanted to move beyond the limitations of the craft into the realm of art.

At high school, his two pastimes were swimming and art. "He was never a star at either," said art teacher and swimming coach John "Coach" Arciniega. "But he gave a lot of himself and had fun in both. Among the better students, Dan was a good artist, but there were others just as good. The same in swimming—he was good and he got the team points in the meets, but he was no standout. He approached both swimming and art with a work-like attitude and seemed to enjoy both immensely."

He battled with most of his art teachers who insisted on controlling the subject matter of the students' work. One teacher went so far as to reward his rebelliousness with a failing grade. He did, however, find allies in Arciniega and John "Duke" Dalton.

"I took all of the art classes I could and never really got much out of them. Duke's class was a senior-level class. It was more philosophy than instruction. He made us think—think about art, about life . . . about everything and how it relates to art," Dan said. "That was a valuable lesson. Creating art, no matter what medium you're working in, requires a great amount of thought before you even pick up a brush, a piece of charcoal, or a sculpting tool. Art just doesn't happen, no matter how talented you are. Duke showed me how to approach, organize, and channel my thinking to create more meaningful work."

Under "Coach" Arciniega's encouragement, Dan submitted work to a competition that earned him a trip to a three-month art program at Kansas State University. This award showed those who doubted Dan's ability and dedication to art that he was truly serious about making a career of it. But once again, he found that school was not the place he wanted to learn about art.

"College art departments place a lot of emphasis on art history and the study of art instead of creating art," Dan said. "I hated it and I didn't learn anything that I needed to create sculpture."

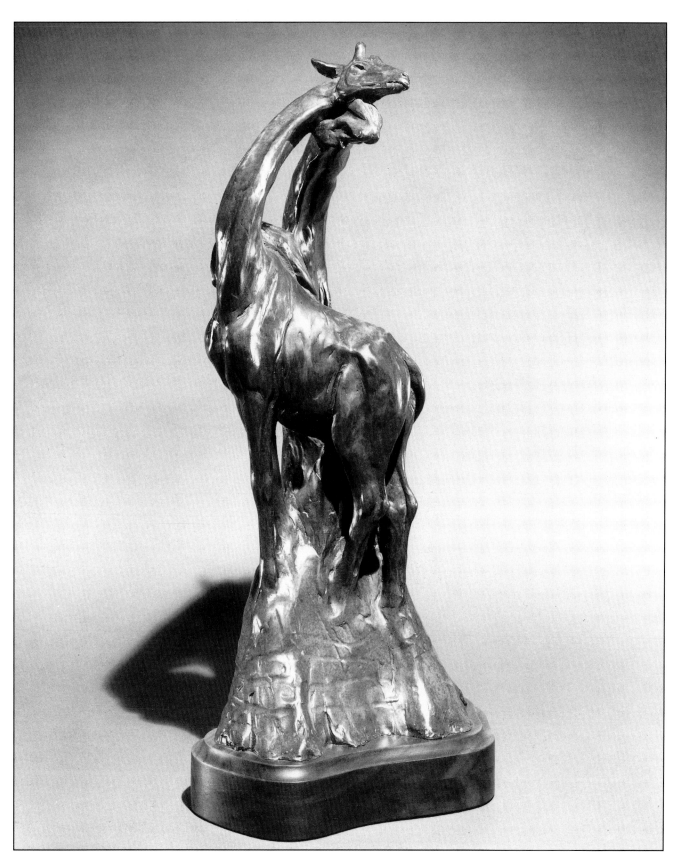

The Scratching Tree, 21″ high, Edition: 12

Chapter III

Gone to Texas

More than once Frontier Taxidermy proved to be a safe harbor whenever Dan's plans went awry. Kansas State had been a setback, but nothing really to worry about. Dan's disposition is naturally cheerful and boisterous and it would take something more catastrophic than this to hold him back from his private plans. He was back in the fold under dad's approving eye, applying himself eagerly to his job and sculpting in his spare time.

Sometimes the best things that happen in life are not planned. While Dan was wondering what his next step would be—college was out and sculpting offered no immediate financial support—a chance meeting decided the next step for him.

Jack Steele, a former University of Texas basketball player, geologist, and extremely large person, was working for a company called Texotic Wildlife that transported "exotics," game animals from Africa, to ranches around the country. In 1975, he and another employee were taking a shipment of axis deer from Kerrville, Texas to Cheyenne. Their contact was Roy Ostermiller at Frontier Taxidermy. Steele stopped in Roy's shop and during their conversation, he mentioned that his employer had a huge ranch near Kerrville that hadn't been commercially hunted in 15 years. The white tail deer population was getting too large and a big hunt was scheduled that promised a harvest of deer with trophy-class antlers.

"There was this young guy there, about 19 or 20, and he said he would like to come down and guide for the hunt," Steele said. "That was the first time I met Dan."

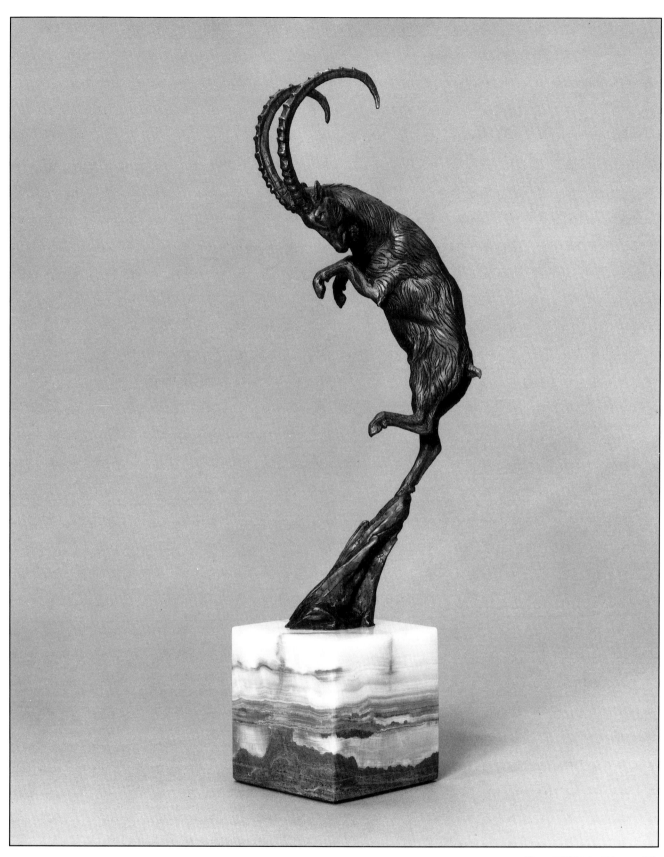

Ibex, 23" high, Edition: 25

During his visit to Cheyenne, Jack hired Dan as one of the guides for the white-tail hunt at the South Fork Ranch near Hunt, Texas. Steele had the dubious honor of organizing all the guides who would take care of 400 hunters during the 55-day hunt.

"There were two other guides Dan's age working the hunt. Every night they were there, these three would go out and try to drink up all the Wild Turkey and beer in town and chase the girls," Steele said. "Well, you can bet they loved me for being the one to get them up in the morning so they could get their hunters fed and on their way for the hunt. I truly believe Danny didn't know there was a 3 a.m. as well as a 3 p.m. before he came to Texas."

Despite the fact that Dan was one of the more experienced guides at the hunt, Steele said that Dan was the only one to get a hunter thrown in jail for shooting an illegal spike buck.

All in all, the two hit it off and when Dan left for home, they had set the foundation for an enduring friendship.

Dan decided he liked Texas—chinoak, cedar brush, limestone and all. And the characters like Jack Steele stood tall in his mind. Life constantly serves up opportunities that seem just too coincidental at times, but it happened that another old character from Dan's past, Lloyd Woodbury, was living near Steele in Kerrville, Texas. He had moved Woodbury Taxidermy from Wyoming to Texas where he mounted animals and, in his spare time, sculpted animals for bronze casting. It also happened that Woodbury decided he needed a young guy to help out around the shop.

In retrospect, it all seems as if it was supposed to happen. It was in Woodbury's Rawlins, Wyoming shop where inspiration first struck Dan, and it would again be Woodbury's shop, this time in Kerrville, where he would learn the craft of bronze sculpting.

Dan called Steele and broke the news that he would be heading down south again soon. Jack invited him to bunk in the other room of his small two-bedroom home just outside of the little Texas town of Ingram.

The fit was a good one. Outside his brief and miserable stint in Kansas, the move to Texas was the first time Dan had truly been out on his own pursuing his dream. Steele was as good a friend as a young guy could hope for—someone to

drink beer and chase women with, and to bail you out when the two got you in trouble. Lloyd and Esther Woodbury were old family friends who loved him like one of their own children. Dan also had the chance to tap a new source of knowledge on animal anatomy and gain a new perspective on taxidermy. More important, he now held the key that opened the door to the world of bronze sculpture.

"He'd work all night if I would have let him," Woodbury said recalling his student's enthusiasm. "I told Roy many times that Dan would be a great sculptor someday if he kept at it."

On the weekends, the oddly sized pair of Jack (six feet seven inches tall) and Dan (five feet six inches) would trap and transport the exotic animals for the company Jack was working for. They drove from one end of Texas to the other delivering animals and, of course, drinking beer.

More than ever, Dan's life revolved around animals. He mounted animals during the day, sculpted them at night, trapped and delivered them on weekends. Every now and then, just for good measure, he'd throw in a hunt or two to break up the routine.

"I think he was becoming an animal," Jack said. "When we'd come back home at night after drinking he would howl towards the home next door where this pretty little girl lived. He said it was his mating call, but I couldn't say if it ever worked or not."

Local women was another area in which Jack was well versed. He introduced Dan to one he highly recommended for dating.

"Shortly after I introduced them Dan calls me and tells me he's getting married," Jack said. "When he told me who it was, I said, 'No, Danny, don't!' You can see how well he respected my opinion. Coming to Texas to work with Lloyd was the best thing that happened to him—until he got married."

On July 7, 1977, Dan jumped into a marriage that was doomed from the start. Not all the problems in the marriage were created by Dan, but a 21-year-old with drive and a dream isn't the best marrying material. After a year of learning to sculpt, eating Texas road dust, washing it down with Lone Star beer, howling at the girls, chasing, mounting, shooting, and sculpting animals, Dan and his new wife packed up their lives and headed to Cheyenne—and a very shaky future.

CHAPTER IV

Off the Path

It was stated previously that following a path leading to a career in art is personally challenging and the way is illuminated only by the glow of imagination and effort. The emotional turmoil and difficulties that Dan met in his early twenties would dull his creative glow to a point where he almost lost the path completely.

Dan and his new wife moved back to Cheyenne and purchased a small house near Frontier's shop. He once again put on the apron and went back to his father's craft. Sculpture was temporarily relegated to a secondary position behind taxidermy.

Shortly after their move north, problems began to arise between the two newlyweds.

"I learned you can never take a Texas woman out of Texas," Dan said.

The demands of an eight-hour-a-day career and a desire to be a great sculptor left room for little else in Dan's life. Although their marriage was less than a year old, he and his wife began to grow apart. A young person trying to express something in art vitally needs encouragement to grow. When he spoke of his dreams, she offered only discouragement.

"My first marriage was a turning point in my life," he said. "It was a real learning experience. There is probably nothing more motivating than to have someone tell me I can't do something. My wife and my father both told me I'd never make it as a sculptor. My wife told me that artists were bizarre people with bizarre ideas and there was no money in it. I guess one of the major problems of being a sculptor is not

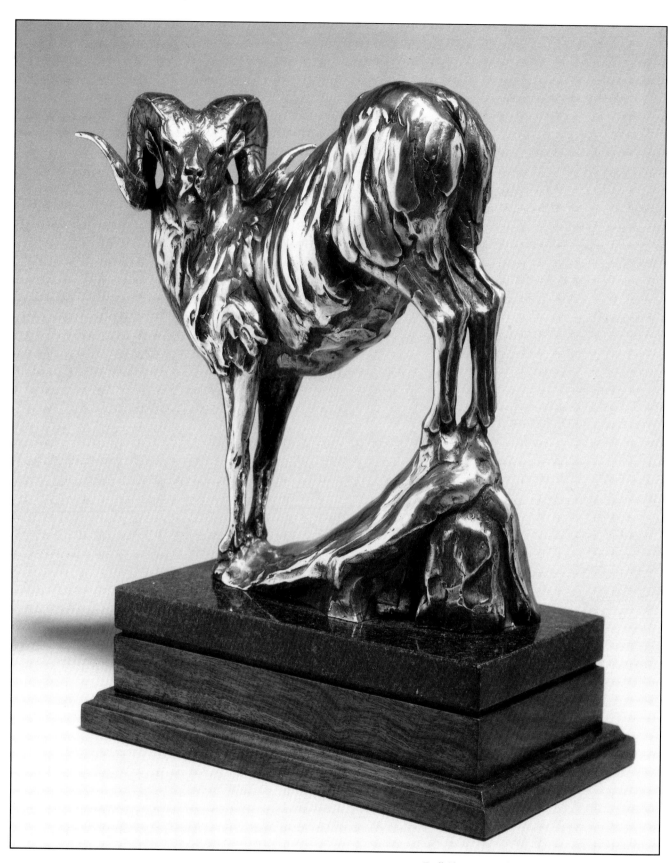

Dall Sheep, Stainless Steel, 14" high, Edition: 20

having a lot of time to share with other people. It's difficult to be so interested in art and still have a lot of room to fluctuate between being a husband, a father, or whatever. You can provide time for those things, but to give your goals your full attention creates conflicts with those other areas.

"That's one thing I've never been able to do in my life is to go in any direction except the direction I'm working towards. It's the same thing with my first wife: I tried to make attempts to appeal to her interests. I tried, but actually, I couldn't. I had to keep my eye on the goal out there and move only in that direction. That's what keeps you on the road to success: determination."

As the marriage slowly eroded, Dan devoted more of his time to his sculpture rather than return to a depressing home life. A man he had met through his father's shop knew Dan's work and offered to represent him as his business manager. Dan took on the so-called partner in 1978, much to his eventual disappointment. Dan's memories and assessment of the man's character are none too flattering. He sold pieces, but, according to Dan, under a lot of false pretenses.

"You know, if you've got a line of bullshit you can sell anything. You can sell used cars. You can sell sculpture," he said. " Dealing with this guy confused me to the point that I didn't know what I wanted. Sure he was selling my work, but the audience he was selling to was not the one I wanted my work to attract."

The situation on the home front was growing progressively worse. His marriage was on the rocks; his work was being represented by a man with all the conviction and dedication of a pimp; he wasn't making a living the way he wanted; and he was the only one providing impetus for his dreams. The situation was ripe for change.

It had been Dan's obsession since he was a child to one day hunt the African bush. It had been a goal since his father came home with colorful stories, reels of 16mm film, and dozens of photographs depicting his African hunts. The opportunity to fulfill that dream came in 1978. A party was

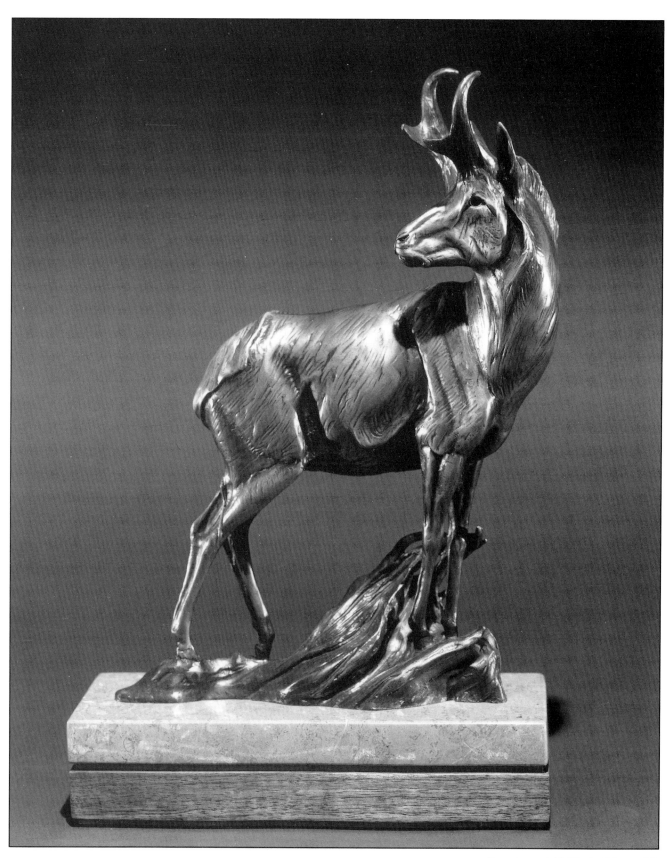

Pronghorn, 14¹/₂″ high, Edition: 20

being organized to hunt the western edge of what is now Zimbabwe (formerly the colony of Rhodesia).

"There wasn't a man, woman, child, or force of nature that was going to keep me from that trip," he said. "Wife or no wife, I was going to Africa."

One of the African guides, Gavin Rabinovitch, would become a lasting friend. Gavin, a fourth-generation Rhodesian, had been raised in the bush and proved himself to be an adept guide for the Americans. They hunted cape buffalo, kudu, and zebra on government hunting ground on a sliver of land wedged between Zambia and Botswana. They hunted near the town of Matetsi, not far from the spectacular Victoria Falls National Park.

The wildness and openness of the African bush was a welcome change from his life in Cheyenne. Back home the walls had been closing in on him. Deep in the bush, he was in his element camping in the wilds, swapping stories with men who shared his love for the hunt, and revelling in the exotic nature of the land. The entire experience started turning some rusty old cogs in Dan's head.

After five weeks of heaven on earth, he was on a plane for home. The refreshing break in Africa brought Dan to the realization that he had to end his marriage to get back to his quest for a livelihood in art. He wasn't quite sure, however, how to go about it. A few short months after his return from Africa, he got wind of another hunting party that would be going for grizzly in Alaska in the coming spring. As he tested the matrimonial waters by dropping the hint that he would like to go, his wife provided an ultimatum: "If you go, you won't find me here when you get back."

"I didn't have to think twice about that one," Dan said. "Here I had a chance for a great hunt and to get rid of my wife at the same time. It was a painless out that really gave both of us an excuse for parting."

Dan went north to Alaska to join one of the most enjoyable hunts of his life. For three weeks the group of seven hunters and 16 pack horses trekked through the Mentasta

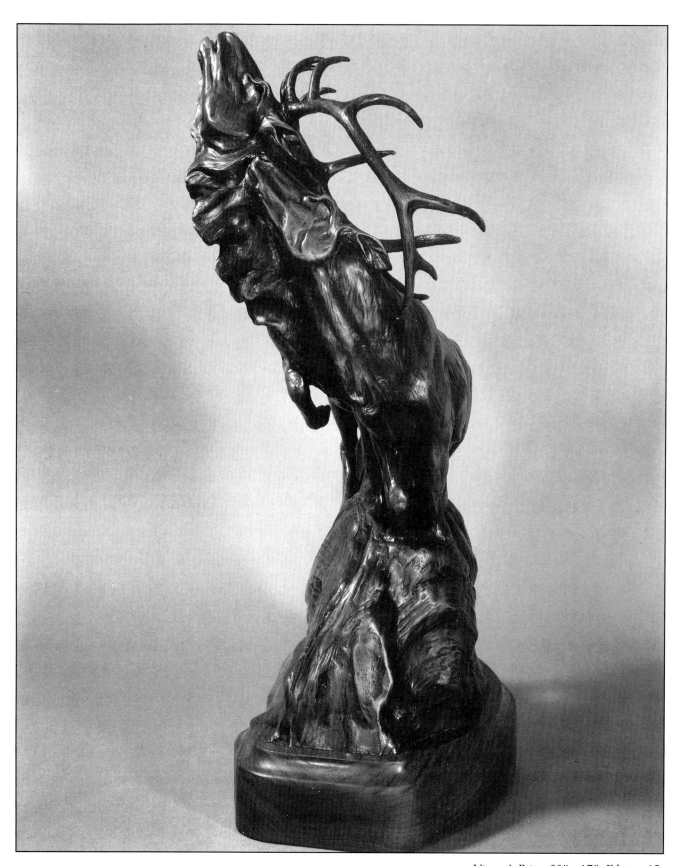

Victory's Prize, 23" x 17", Edition: 15

Mountains just across the Alaskan-Canadian border near the town of Tok. Just as in Africa, the hunt brought a much needed infusion of freedom and inspiration for the stifled artist. The experience was therapeutic for the newly liberated man.

When he returned home, he found his wife had made good on her promise and had returned to Texas, leaving their little home empty for Dan to fill up with another life.

"In 1979, I did some serious house cleaning. I got rid of everyone and everything that didn't reinforce my dream to be an artist. I divorced my wife, I dumped my so-called manager, and quit my dad's business to go into sculpting full time. It was a year my life took quite a different turn—a turn I knew I had to make if I was going to be serious about being a sculptor."

"You'll be back," were his father's parting words. They were a gentle rebuke for forsaking the future his father had created for him. They were words that smoldered on the surface of Dan's consciousness. Over the next few years when the outlook was bleak, his father's prediction and his former wife's pessimism would renew his determination to succeed.

For anybody or any situation, tearing down to rebuild is often necessary, but always difficult. It's recognizing and admitting that the direction previously taken was the wrong one; it requires backtracking until a more useful route can be found. The search can be a confusing one with no clear path through unexplored terrain. A new route has to be hacked out and blazed with blind confidence and intuition.

The change in direction proved to be a long arduous trail for Dan. All of the sculpture he had created before this change was what he calls "taxidermy realism" and his primary market had been hunters who weren't exactly the most discerning art collectors.

"I'm not saying that none of them had an eye for design and line, but that didn't matter at all for most of them. If it had a big rack, it was great. They wanted an animal to be posed just as one they killed looked just before they shot it. The people in this market wanted a sculpture to depict an

image they had in their head and I was playing to their tune. By going along with that, I was being trapped by their desires and the narrowness of the market I was catering to."

Dan began to experiment with his designs, pushing them to extremes and seeing what became of them. Some failed. Some worked. None were financially successful. The hunters no longer saw what they wanted in the animals Dan created and the few financially sustaining sales from them fell off. They may not have had an eye for art, but their appreciation of more superficial work had put money in his pocket.

"I was experimenting and sculpting animals the way I thought they had to be done. I ended up with pieces that people didn't necessarily like so much. I was questioning my creativity and doubting my talent. The money meant nothing. The pieces I was producing for the hunters' market weren't making any kind of statement. I thought I was so far off track that nobody was getting my point. Sculpture is a personal expression and I had found a new way of expressing myself. The problem was, apparently nobody was understanding what I was trying to accomplish. It frustrated the hell out of me. I knew I had to change. I had to do something different than anyone else."

He had backtracked and picked another route, but the new route was a precarious one along a trail with a long drop on one side. By his own admission, this was the closest he would come to falling completely off the path that led to his ultimate goal.

CHAPTER V

Loveland

The great melting pot for the sculpting world is the foundry. After the lonely struggle to shape a lump of lifeless clay into a semblance of an image from the artists head, it must be cast into metal. By the luck of the draw, a quality foundry was located only 60 miles to the south of Cheyenne in Loveland, Colorado. Art Castings of Colorado is where Dan would meet with some of the most important developments in both career and personal life. It would also serve as the cornerstone for the community's flourishing sculpting/art community in which Dan has played, and continues to play, a large influential and developmental role.

Art Castings became a bronze foundry almost by accident. It was founded in the '60s by Bob Zimmerman, a metallurgist trained at the prestigious Colorado School of Mines in Golden, Colorado. After working for large industries such as Morton-Thiokol and General Motors he moved to Loveland and opened his own foundry. His first contracts were for industrial parts, one of which drove the shop into bankruptcy in the early '70s.

There was no art community in the Colorado town of 35,000 at that time, but a few of the founding influences were already in place. Two of these were Fritz White, a talented and irascible sculptor who would become Dan's friend, ally and influence, and George Walbye, an artist who was sculpting and selling cars. The two were aware of Zimmerman's vast knowledge of metals and castings and sought him out to see if they could get some of their work cast.

"Although the place was in bankruptcy, Bob still had the key to the building," Loveland sculptor George Lundeen remembers. "Fritz and George would bring their sculpture down at night and Bob would open it up and do some casting for them. After about six months, Bob had built up a savings and went to the bank and made a pretty hefty payment. They asked him where he got the money and he told them he'd been using the foundry at night. Needless to say, the bankers didn't discourage him from opening the place again."

Foundries in the western United States are few and far between, and a good foundry, from the perspective of an artist, is nearly non-existent. It didn't take long for word of Zimmerman and his foundry to spread through the artists' grapevine and attract a number of notable sculptors to the area.

Lundeen had been an art teacher in his home state of Nebraska and in Italy. Working among a tradition of craftsmanship in the Italian foundries, he observed what rich works a conscientious foundry could produce.

The majesty and accurate depiction of "American Gold" has made it a popular monumental piece gracing parks and clubs around the country.

"When I got back to the states, I had to start a new foundry everywhere I went because it seemed nobody knew how to cast sculpture. I was visiting a friend in Longmont (Colorado) and I had a piece I was working on at the time. I needed to get it sandblasted and my friend suggested Zimmerman's down in Loveland. I walked in the front door and asked if I could use their sandblaster and they said sure, it was in the back. It took me about 10 minutes to get back there because I stopped and watched these people work. They really knew what they were doing. I walked back to the front and picked up the phone and called a

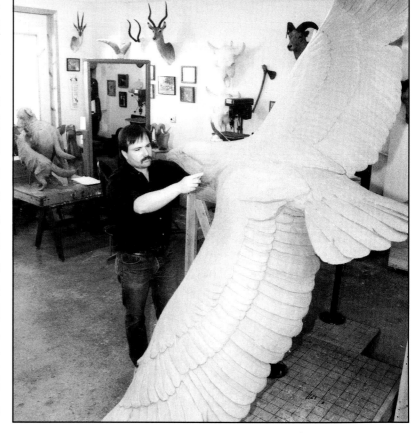

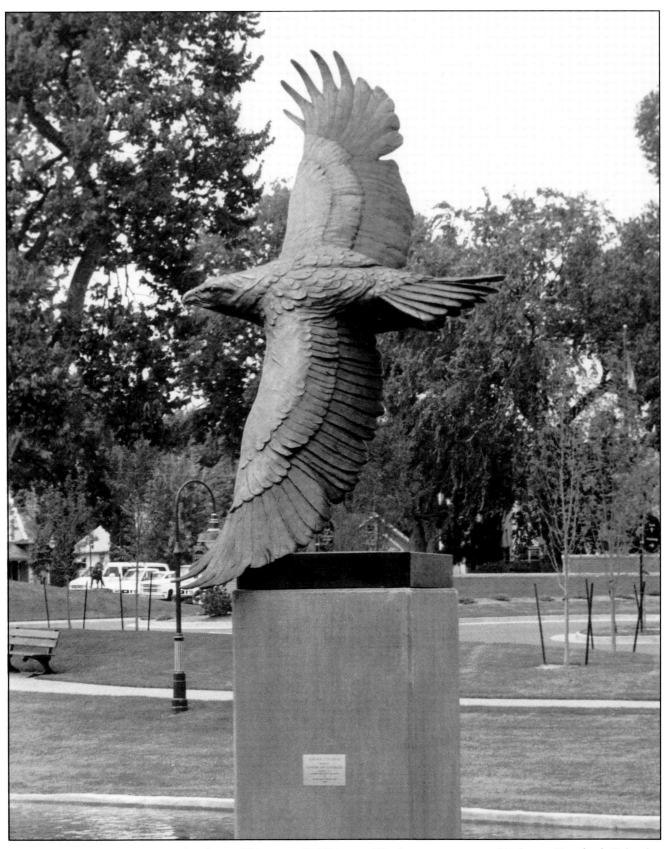

An edition of "American Gold" is one of Dan's many pieces around his home of Loveland, Colorado.
The eagle stands next to a reflecting pond at the community's civic center.

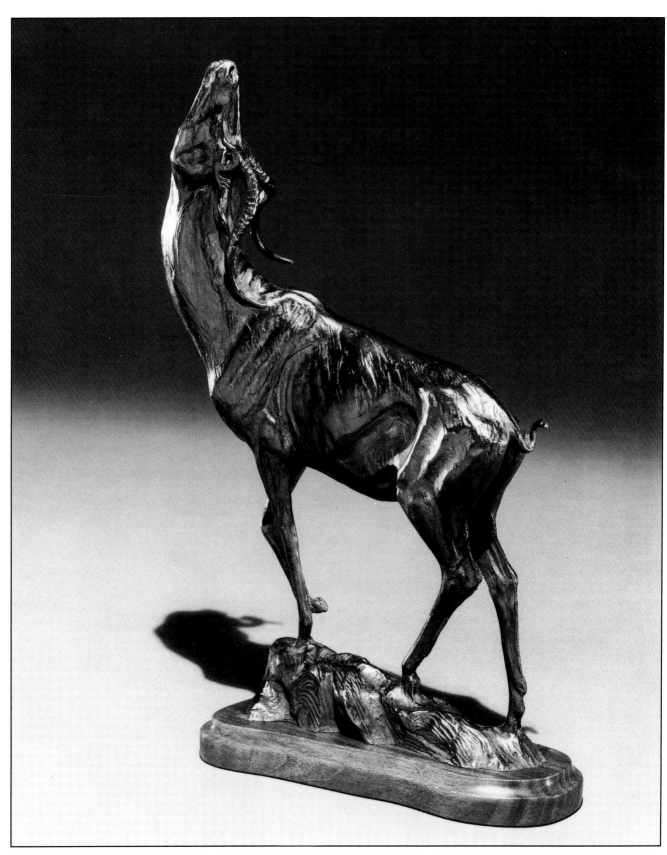

Impala Ram, 13¹/₂" x 8¹/₂", Edition: 20

real-estate agent and asked him to start looking for a home for me."

When Dan began casting his early works shortly after his return from Texas, Loveland was already fertile ground for learning more about sculpture. In addition to White and Lundeen, who would become his friends and artistic associates, he also met other notable sculptors including Hollis Williford, Tom Schomberg, Jon Zahourek, Ken Bunn, Terry Kelsey, Glenna Goodacre, and Herb Mignery. The foundry served as a social and professional rendezvous where artists could see what their contemporaries were doing and discuss technique, style, and theory in relation to sculpture.

His years of taxidermy comprised his primary education. His secondary education came in Texas when he learned to sculpt with Lloyd Woodbury. In Loveland, the intensity and quality of what he was learning was equivalent to graduate school. Here he would talk with sculptors of his own level of experience and others who were established in galleries and shows across the country. He would learn the aspects of marketing and selling sculpture as well as theory and practice of execution. It was the type of education any young artist would welcome.

At the foundry, Dan met one of the greatest influences on his career in Fritz White. Fritz, who is 27 years Dan's senior, is known around the Loveland art community as a hell of a sculptor, a brutally frank critic, and an all-around ornery ol' boy. He and sculptor Herb Mignery are the only two Colorado representatives of the exclusive Cowboy Artists of America.

"The first time I really met Fritz was at George Lundeen's show in Taos, New Mexico, nine years ago," Dan said. "We kind of hit it off after that. Fritz is old enough to be my father, but he's one of my best friends. I've never met a person who can critique sculpture better than Fritz White. He has an incredible eye for design."

That critical eye has been run over many of Dan's sculptures while Dan stood anxiously by. Whatever Fritz White

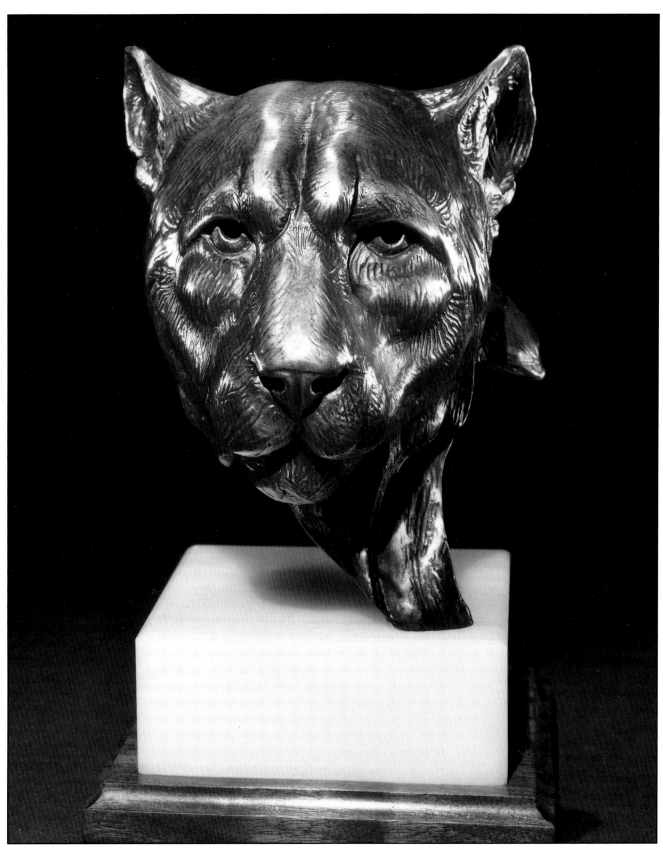

Mountain Lion Portrait, 10¹/₂" x 7¹/₂", Edition: 20

thought of his work, Dan was perfectly willing to listen and weigh his advice.

"My first impression of him was that he was better than he actually was," Fritz White said. "He was a raw amateur . . . not an amateur . . . more of a raw professional. If I had any criticism of his work at the time, it was that his stuff was too damned cute. He was searching for something and maybe cuteness was the result. It was obvious he was searching for the soul. It was also obvious that he knew where he wanted to go with his art. His early pieces had a lot more spirit and character than they did actual physical resemblance. What that means is that Dan was starting off on a better foot than many sculptors. There was so much of himself in them. He interpreted animals instead of creating mirror images," he said.

Fritz had the opportunity to meet Roy Ostermiller and enjoy both the father's and son's perspectives on life. Together on a buffalo hunt in Thermopolis, Wyoming, the three formed an association Fritz dubbed the Steaming Liver Eaters of America.

"When the Indians and the plainsmen killed a buffalo, the first thing they ran for was the liver—cut it out and ate it raw," Fritz said. "When Danny shot that buffalo, we gutted him and the three of us ate the liver raw. It was well below zero and it just steamed.

"Danny said he dropped that buffalo in two shots," Fritz said jokingly. "The first shot hit him right in the halter rope."

Another Loveland artist Dan came to know as a familiar face at the foundry is sculptor Hollis Williford.

"What impressed me about Danny is how hard he works—and still works. He is as prolific as anyone I've ever known at the foundry," Hollis said. "He kept working at his craft, originality, and art. His foundation in taxidermy work gave him solid foundation in his subject matter.

"At the time I met him, his hands hadn't caught up with his skill. Objectively, he wasn't able to achieve with his hands what he knew about his subject. Dan has made great strides as

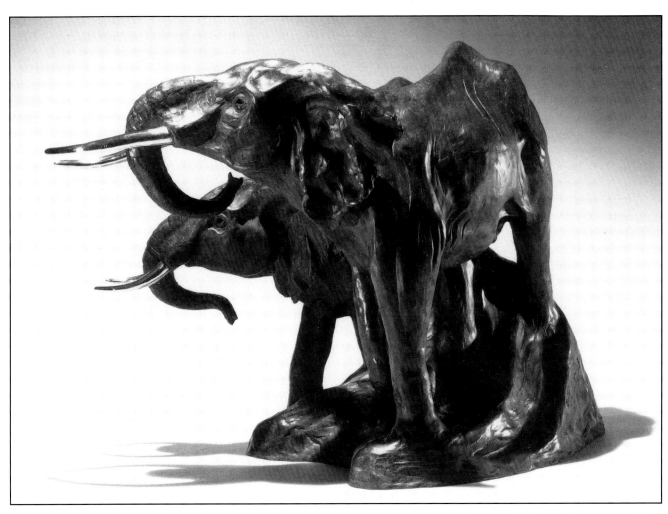

The Escort, 17^1/$_2$" x 24", Edition: 10

an artist. It's been pleasant to watch a guy through the years work with an intensity like Dan's and to see some great results."

Loveland provided this small cadre of artists a refreshingly new place to exchange ideas and to grow. They also enjoyed the enthusiasm of young artists like Dan who sought them out and eagerly drank up the advice that flowed freely at the foundry, restaurants, studios, and anywhere else they congregated.

Not only were there artists coming to town to be near the fledgling art scene, but peripheral people like skilled foundry workers and students of art also trickled into Loveland as its reputation grew. One of these people was Betsy Rotz. A graduate of a small Pennsylvania college with a degree in art education and textile design, Betsy came west to the foundry to work on a masters degree. She worked in the front office of Art Castings greeting and tending to the needs of the diverse mix of artists who came through the door. Of course, one individual who came through the door often was Dan Ostermiller.

As the two got to know each other, they found they held common interests—art was the major one. He found her knowledge of art varied and deep while she saw promise in the early pieces he was casting.

"I thought his early work was . . . it was pretty awful," she said with a laugh. "Dan has always had a very good sense of design in his work, especially the lines he uses. The execution of the actual piece wasn't always real wonderful. This was back in the days when his taxidermy background took over and he'd put in a hundred hairs scratched into the surface so it would look real. I think that's the way a lot of people start out—they feel they need to make something look very real. He graduated into a more stylized technique with his animals. The basic design of the pieces was always good, so I knew the kid had talent," she laughed.

The "kid" was ten years younger than Betsy, but it mattered little to either. Soon after their meeting, Dan gave up his home in Cheyenne and moved south to Fort Collins, a thriving college town 15 miles north of Loveland. Betsy was

to provide guidance and an influence that would get Dan's career off the ground floor.

"I wasn't selling a damned thing," Dan said, "and we were broke, broke, broke. I couldn't get into any galleries being an unknown. I'd never even had my own show. Then Betsy said, 'Well, let's put together our own show.' It was things like that that amazed me about her. Here I thought getting these things together was so complicated, but she knew enough about them that it all seemed so simple. We printed up invitations and scheduled the show at Dad's shop in Cheyenne for August 8, 1980.

"Betsy also took care of the refreshments and things like that," Dan said. "I made these little animal reliefs and we molded them in rubber. Betsy used them to pour chocolate and cheese party favors to serve at the show. We came home the next night and someone—probably some kids—had torn off a window screen and the only thing in the whole house that they had taken was these chocolates. I bet those were some sick kids when they were through."

The show was a great success. The sales included two editions of The Escort with a price tag of $5,500 each, easily the most expensive piece he had ever produced, let alone sold.

"That is my lifesaver piece," he said pointing at The Escort. "Before that show, there was a long dry spell when I hadn't sold much. The money we made off of those two pieces was enough to get the creditors off of my back and put money in the bank that we lived on for a long time. That piece is still one of my favorites."

The success of the show breathed new life into Dan's artistic confidence and propelled him deeper into his work. By the beginning of 1981, positive things were beginning to happen for him. It was a banner year for Dan: his work appeared in five shows in New York, Colorado, and Wyoming. He was also voted into the membership of the of the New York-based Society of Animal Artists. Recognition outside the West was finally coming his way.

He and Betsy were married in 1981 in the Boulder home

of sculptor Glenna Goodacre in a ceremony that was short on formality and long on raucous fun.

"The vows took about two minutes and as soon as I said 'I do,' Bill Goodacre shoved a beer in my hand and the party commenced," Dan said.

He ended up losing the skin off the top of his toes while being half dragged and half carried to a friend's car and he woke up in the morning in someone else's clothes—there had been an unscheduled free-for-all in the Goodacres' pool that left plenty of spare clothes lying around the house.

They moved to Loveland where Betsy continued working at the foundry and Dan took over their garage as his studio. As always, he applied himself diligently, disappearing into the garage/studio when Betsy went off to work at the foundry, still working there when she returned. Success was coming, but there is always the price to pay.

"Danny is intensely serious about his art," Steve Elliott, a Loveland wildlife painter, said. "There are two kinds of artists in this world. If you gave both types $5 million, one would be playing tennis and hanging out at the country club, never touching his art again. The other would be up the next morning and back at work at his art.

Dan proudly poses with the monumental clay "Buffalo" before preparing it for mold.

"Danny is of the second type."

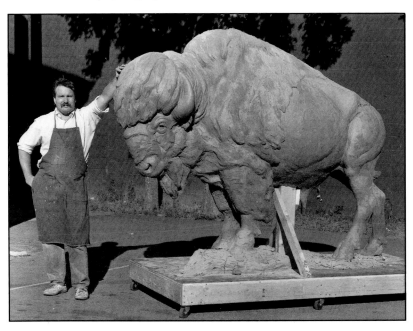

He certainly didn't have millions of dollars, but the desire to be an artist that had been born in him years ago had not diminished. When he wasn't sequestered in his studio, he was at the foundry or at an associate's studio discussing art, or out photographing and sketching animals to be added to his extensive reference files. He wasn't rich, but he was making a living from his art. That in itself was a realization of a large part of his dream.

51

In 1982, he took another sabbatical from his work to hunt and photograph African animals with his friend and guide Gavin Rabinovitch.

"I love Africa. I'd love to live in Africa," Dan said. "It's just not possible, though. I truly enjoy going on safari and living in the bush, but when I'm gone for a while I start getting these great ideas for sculpture. I get pumped up about a piece or a bunch of pieces and I've got to get back in the studio and get to work. As much as I'd love to pitch everything and go, I couldn't. I have to sculpt or I'd die."

At the time of his return to Loveland, there were artists in the community, but as yet there was no art community. Besides the foundry and casual friendship among the artists, no unifying factor had emerged to meld the artists into a cohesive group. Dan had learned that sitting around waiting for something to happen can be a long wait. From his experience organizing his first show, he knew that sometimes a guy has to take the bull by the horns and make things happen. In December 1982, what has become known as the "original five"— Dan, Fritz White, George Lundeen, Hollis Williford, and George Walbye— put together a show at George Lundeen's studio in downtown Loveland. Billed as "An Exhibition of Fine Art," the show featured a dozen local artists. The interest generated within the community from the grassroots show set the stage for greater things to come.

A group of Loveland residents was interested in working to enhance the community with the talent and energy the artists had brought to town. The group of non-artists organized the Loveland High Plains Art Council. The major accomplishment of this group was to lobby the Loveland City Council for the creation of a sculpture park in one of the city's more undeveloped open areas. The council unanimously passed a resolution giving LPHAC the authority to place in the park sculpture purchased with its own funds.

Dan's first monumental piece, two snuggling rabbits entitled A Friend Indeed, was the art council's initial selection for placement in the park.

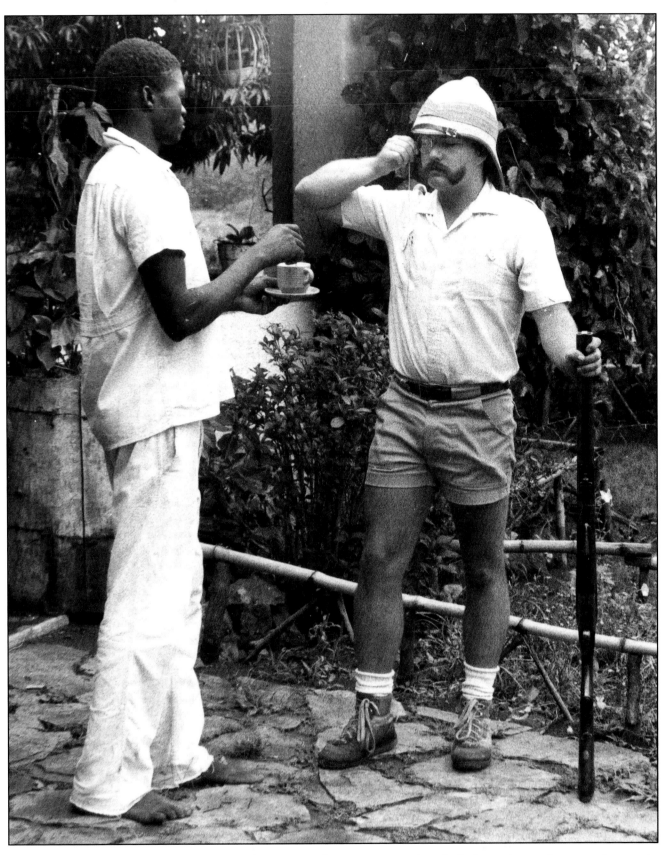

The great white hunter takes tea—and some time out for a little fun posing with gun and monocle during his second trip to Africa.

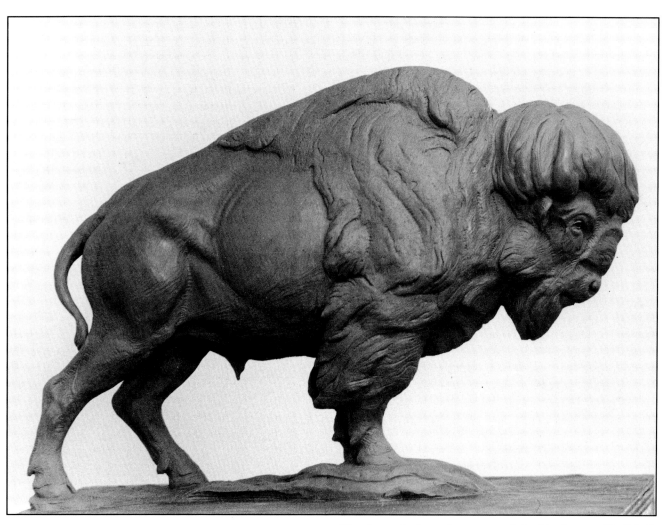

The clay study shows the texture and detail in the piece "Buffalo."

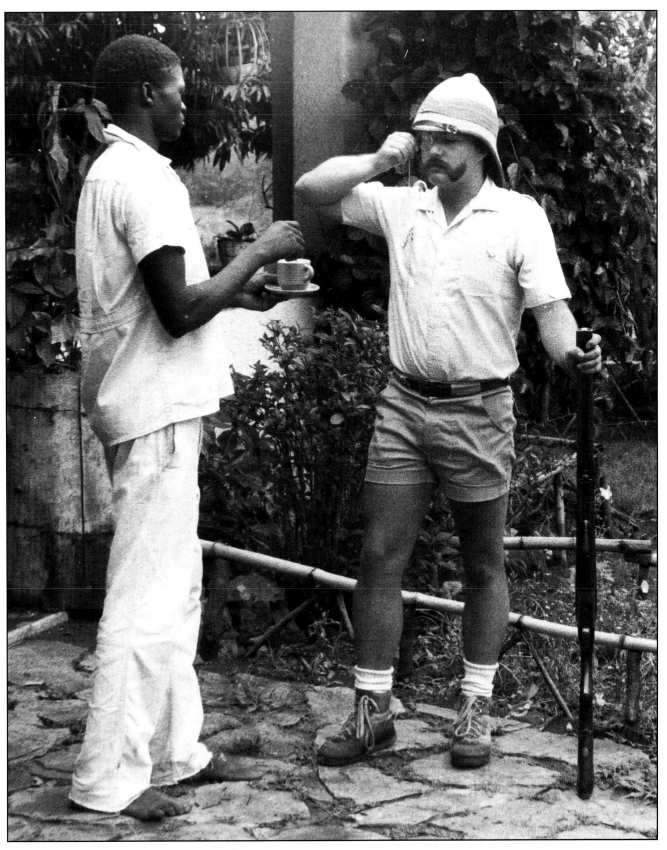

The great white hunter takes tea—and some time out for a little fun posing with gun and monocle during his second trip to Africa.

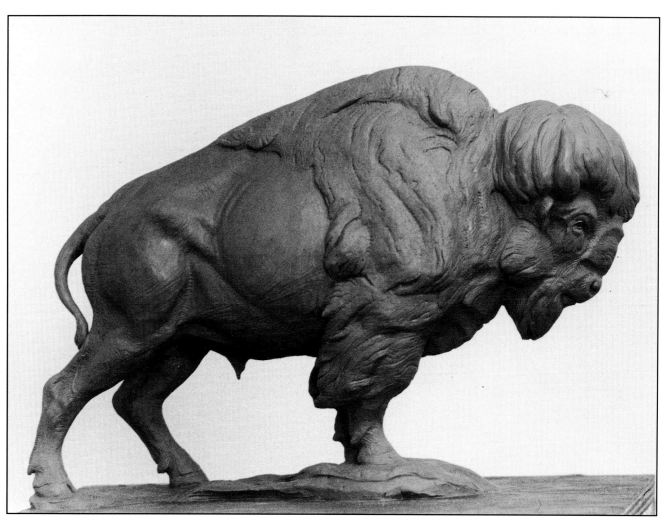

The clay study shows the texture and detail in the piece "Buffalo."

To raise funds for purchasing sculpture, the council held an outdoor sculpture show and sale in August 1984. It became an annual event and Sculpture in the Park grew to be the nation's largest outdoor sculpture show. Dan served as the show's chairman from its conception through the 1989 show.

"Guys like Dan were instrumental in the High Plains Art Council and Sculpture in the Park," Hollis Williford said. "We all contributed to it for no other reason except we felt like there was a need to educate people about the sculptural state of the art. We felt that sculpture wasn't made as important as it should be as an art form. We wanted to do something that would make sculpture more important because we're accustomed to being used as door stops in the galleries and play second fiddle to painting. We wanted a celebration of sculptural art forms. We wanted to have sculpture have its due. We wanted equal billing with all other mediums and felt like it wasn't getting its fair share of exposure and understanding. It's still an educational effort. It is also a reason to get together as artists. We could see that just the momentum here in our little community among the sculptors is growing and productive. We thought if we could get 100 or 200 sculptors together in one spot one time a year, that could serve as an objective exchange of interests and intensity and information. It's become a sculptors' rendezvous. That to us is the most important part of the show. Even if it hadn't become such a success, we'd probably still be doing it."

Loveland had found the art community to be a financial and spiritual shot in the arm. Like so many small towns in mid-America, its main street was in decay from a soft agrarian-based economy and from losing commerce to the larger, more commercially developed communities nearby. As the artists moved in, they pumped new life into vacant buildings by setting up studios to carry out their trade. Sculpture in the Park annually brings the city over a quarter million dollars in sales from nearly 250 sculptors, and the residual sales from thousands of people pouring into town for the show.

The city went so far as to pass a 1-percent sales tax to purchase public art to adorn its parks, streets, and public buildings. People entering Loveland from the north on U.S. 287 are greeted by Fritz White's The Winning of the Ironshirt. Among the 30 sculptures purchased for Benson Sculpture Park are Dan's A Friend Indeed and Heart and Sole, Glenna Goodacre's Girl With Ribbons, George Lundeen's Prairie Flowers, and Hollis Williford's Great Blue Heron. Placed around the town's civic center are other pieces, including Williford's A Need to Know outside the entrance of the public library; Bonnie—a sculpture of a shetland pony Dan did on commission for long-time Loveland resident and teacher Lillian Akers—outside the municipal building; and Dan's American Gold on one side of a reflecting pond and Lundeen's The Story of Music on the other. (Among the figures in the Story of Music, Lundeen used himself as the model for a bass violin player and Dan for a tuxedoed fiddle player.)

Loveland and the artists proved to be a good match. The artists found technical support in the foundry and spiritual and moral support from each other. The community provided nurturing financial support. The full circle was being built. For Dan and for a number of other aspiring artists, it was the place to be if you wanted to be a sculptor.

"It's like a lot of things that start and grow—there's no reason for it to happen, it just happens. Schools of art come from ideas or a group of people getting together and it grows within itself. These things can't be planned. Communities may say, 'Oh, we need to start an art colony.' Well, art colonies aren't started because the chamber of commerce or civic group says we've got to invite artists to move here. The catalyst in Loveland has been the foundry. Everybody has to have one and that's why they come here. It also happens to be a place they want to be. That's how art movements start. They aren't planned; they just happen. You start planning it and regimenting the creative process and you're already in trouble. It's like a flock of shepherds."

"Sculptors probably have more respect in this town than any other town short of Florence, Italy," George Lundeen said. "As time goes on, we'll probably have the same type of spirit towards sculptors as in Florence."

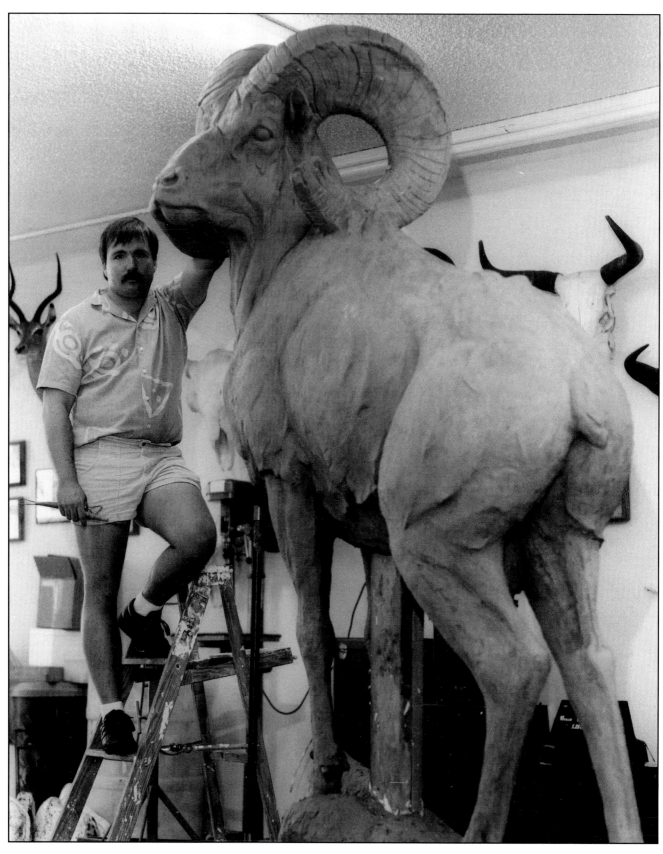

This bighorn sheep is part of "Mountain Legacy," a commission by the city of Estes Park, Colo. The piece greets over a million tourists a year on U.S. Hwy. 34 that passes through Rocky Mountain National Park.

CHAPTER VI

Life Goes On

In Loveland Dan found stability. Betsy continued to work at Art Castings and he worked out of the garage producing more sophisticated work which also proved to be more commercially acceptable, but not until 1986 did his sculpture truly become profitable. With his newly found success he also took on more responsibility. In 1985, he became a father when Betsy gave birth to their daughter Lauren on April 16. He also became a man of property when he and George Lundeen purchased a building in downtown Loveland to provide the growing number of sculptors in town with studio space. The building now serves as Dan's studio with an apartment and studio available to sculptors stopping in town to cast pieces at the foundry. He took on a full-time staff of helpers and apprentices who now depend on his creativity to provide them with an income. Within the community, he had hesitantly been pushed into a leadership role by his association with the High Plains Art Council and his chairmanship of Sculpture in the Park. The Ostermillers' lives were firmly rooted in Loveland and the road ahead looked smoother than it had in a long time.

After a year off from having the baby, Betsy was looking for something to occupy her time. In June 1987, opportunity knocked. Bob Zimmerman sold Art Castings, which sent a ripple of uncertainty through the sculpting community. Betsy and a former Art Castings cohort teamed up to open a bronze-casting finishing shop of their own. A pouring floor was added within the year and the town's second foundry,

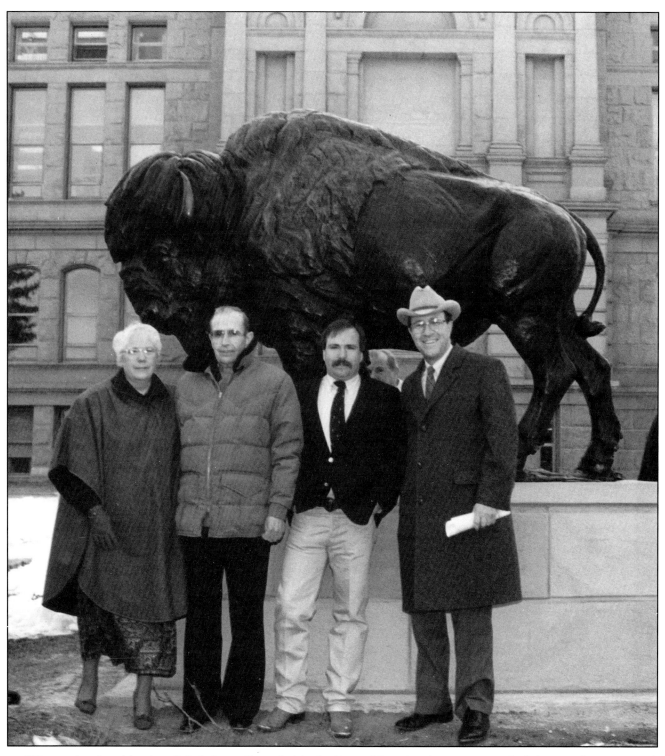

"The proudest day of their lives," Ruth Ostermiller said of the day Roy and Dan shared center stage at the dedication of a monumental edition of "Buffalo" outside of the Wyoming state capital. Pictured are Ruth, Roy and Dan Ostermiller with Governor Mike Sullivan.

Loveland Sculpture Works, came to be. Dan and Betsy were again a family with two careers—both of which revolved around sculpture.

This period literally became a monumental time for Dan. Beginning in 1985 with his first monumental-sized sculpture, A Friend Indeed, Dan discovered he had a natural talent for bringing sculpture up from small pieces to life size and larger than life. It was another component from his taxidermy training which fit nicely with sculpture. In 1987, he was commissioned by Trammel Crow Company to create a monumental sculpture of a buffalo for placement outside the company's corporate offices in Chicago. Dan knew where to find the perfect model: the buffalo he had shot in Wyoming that had the dubious honor of being the donor for the first and only meeting of the Steaming Liver Eaters of America. Roy had mounted the buffalo and it had been placed inside the Wyoming state capital.

One of the editions of Buffalo was placed on display at the 1987 Governor's Invitational Art Show and Sale in Dan's hometown of Cheyenne. The buffalo, which is the Wyoming state animal and appears on the state flag, stirred up a little magic at the show.

"It was the first night of the show," Wyoming Governor Mike Sullivan remembers. "Someone looked at the buffalo and thought of the state. A suggestion spread through the crowd that the buffalo sculpture should be bought and placed right here in Cheyenne. Over the course of the night, 45 people donated $1,000 each to buy it. It was a rather spontaneous reaction."

"Sales like that are things most artists only dream of," Dan said.

The installation of that piece marked a triumph for Dan.

It was chilly on February 26, the day of the dedication on the south lawn of the state capital. Dan was 31 years old and at center stage receiving attention from the governor, the press, and the people of his hometown. But, what made Dan the proudest that day was sharing center stage with his father, who was dying of cancer.

"Dad was in the hospital and we didn't think he'd be getting out," Robin Ostermiller said. "He raised hell with the doctors and told them he was going to the dedication if it was the last thing he did."

Many of the doctors believed it would be the last thing he did. Roy climbed into a wheelchair and was escorted by a doctor to the dedication of a piece with great significance for him. He had been with Dan and Fritz when the model for the piece had been shot; he had mounted the buffalo; and, in a touch of irony, the buffalo Roy had mounted stood on the inside of the capital where the bronze created by his son would stand on the outside. Most important, his son—the sculptor—had created this work which would be on display for years to come.

"He was right up there at the podium with Dan and the governor," Robin said. "Dan dedicated the piece to Dad. It was very emotional. It meant a lot to Dad to be there with Danny."

Here was the man who had introduced his son to the outdoors, and who had passed on the love and respect he had for it. A man who had groomed his only male child to take over in the family business and carry on the tradition he had founded. He had been a frustrated father whose dreams had been overruled by those of his son, but had managed to overcome his frustration to become one of his son's greatest fans and admirers of his work.

"It was probably the proudest day of both their lives," Ruth Ostermiller said.

Three weeks after the dedication, Roy Ostermiller died.

"I had the opportunity for my father to tell me that he was proud of what I had accomplished (as a sculptor)," Dan said. "That was something he never got to hear his father say, and he was as successful in his field as I will ever be in mine."

Although his father had accepted and eventually supported his decision to become a sculptor, there was no longer any need for Dan to prove anything to anyone—except to himself. He had proven that he was a sculptor, but now he needed to prove that he could be a great success as a sculptor.

In 1986, while acting as the director of Sculpture in the Park, Dan was introduced to Nedra Matteucci, a gallery owner from Santa Fe who had come to Loveland in search of new artists to add to those showing at her gallery. She was drawn to the energy and grace Dan displayed in his pieces at the show. After viewing more of his work and talking with him, she decided Dan's sculpture and her gallery, Nedra Matteucci Fine Arts, would be a good match.

It was more than that. Dan calls his association with Nedra, "the second most important factor in the development of my career, directly behind my training as a taxidermist."

A native of New Mexico who had worked with art exhibitions around the Southwest and at Santa Fe's premier gallery, Fenn Galleries, Nedra possessed a deep knowledge of the area's art market as well as the insight and diplomatic skills essential to a successful art dealer. Dan's work sold well at her gallery and she made some important connections for Dan which turned into big sales and commissions for pieces. In 1988, Nedra and her former employer, Forrest Fenn, discussed the possibility of holding a show of Dan's work at the prestigious Fenn Galleries. Based on his 17 years as a gallery owner, Forrest warned her that shows featuring animal artists were not successful, but her confidence in Dan and his work convinced her to proceed with the plans for the show. Her intuitive feelings about Dan paid off handsomely: the show was a success for Nedra, Dan, and Fenn Galleries. It also made Forrest a believer that animal art can sell well after all.

"In Nedra and Forrest I found two great supporters for my work," Dan said. "Nedra was the first dealer to really believe in my work as something other than just decoration. Her faith in me

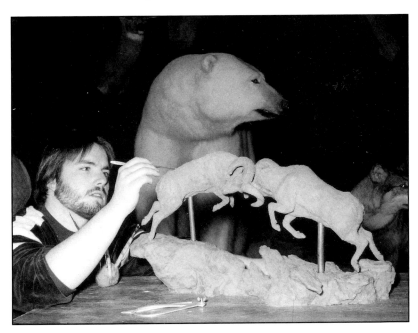

Early works, including this study of two bighorn rams entitled "The Clash," were signed Dan-O.

63

brought Forrest into my camp and it's been a great relationship for all of us."

In the fall of 1988, Nedra and her husband Richard purchased Fenn Galleries and its rich tradition as one of the finest galleries in the nation. She continued to own and operate Nedra Matteucci Fine Arts which nicely complemented the new acquisition. Her intent with Nedra Matteucci Fine Arts was to showcase refreshing new artists which balanced nicely with the works displayed at Fenn of famous artists from the late 19th and early 20th centuries—many from the Taos Society who found the open western landscape and colorful native Indian culture a creatively invigorating environment. In her move to the proprietorship of Fenn, she brought Dan's work with her to be displayed alongside the works of such renowned artists as Georgia O'Keefe, Frederic Remington, Nicolai Fechin, Leon Gaspard, Wilson Hurley and Henrietta Wyeth.

"I owe a lot to Nedra," Dan said. "She worked to get me into some very important collections and has brought me a number of private commissions. Her dedication has brought some very important exposure and recognition to my work."

Dan's faith in Nedra as his representative prompted him to drop all other galleries, making Fenn Galleries and Nedra Matteucci Fine Arts his exclusive outlets.

Not all of the exposure Nedra has gotten Dan has come from her galleries. One incident attracted more public attention to Nedra and Dan than if it had been orchestrated by a public-relations firm. For a number of years Nedra had maintained a street median in the city's Adopt a Median program, often placing works of art in the median to enhance the streets of a city that prides itself as a haven for those who create and buy art. When she placed the 1,400-pound bronze Buffalo on the median—with the private blessing of the mayor—some slighted members of the city council called for its removal as a civic hazard and a potential liability. When the press and the public got wind of the controversy, there was an almost instantaneous reaction from Santa Fe's citizenry to

block the council's move with the formation of a group calling itself Save Our Buffalo (S.O.B.). Flinching from the public backlash, the council voted 6-2 to rescind its earlier measure and allowed Buffalo to graze peacefully.

"I believe any attention given to public art is healthy," Dan said. "Controversy always stirs up emotion and beneficial debate on the role of art in our lives. And," he laughed, "it can't hurt me as long as they spell my name right."

Dan's monumental works have the natural tendency to stir emotion with many people. At the 1988 Governor's Invitational Art Show—exactly a year after the spontaneous sale of Buffalo to the state of Wyoming—another story unfolded about one of Dan's pieces moving someone emotionally and prompting her to action.

Governor Sullivan and his wife Jane were accompanied to the show by friend Josie Orr, wife of then-governor of Indiana Robert Orr.

"Josie and I walked into the show and saw Dan's eagle (American Gold). She saw the piece and said, 'I know just where that has to go—to Eagle Creek Park in Indianapolis.'"

Mrs. Orr returned to Indiana and immediately called her friend Mrs. Samuel (Lisa) Sutphin.

"Mrs. Orr saw Dan's piece and brought back a photograph which I saw," Mrs. Sutphin said. "She was very enthusiastic about it and I fell in love with it. My husband had been on the board of the National Audubon Society and we had taken many trips together with the board and to meetings. There were two occasions where we saw eagles that stand out in my mind: once we flew over Admiralty Island in Alaska, the nesting grounds for the bald eagle, and when we saw golden eagles soaring over the Rocky Mountains as we floated the Colorado River.

"This was such a striking sculpture it seemed to be a natural fit into Eagle Creek Park. We had lived there before it became a park and the eagle seemed to be a symbol or personification of my husband and I—we had done all those things together and the eagle was a symbol of the trips we had taken

together. It was a fitting memorial to my husband."

American Gold was placed in the nation's largest municipal park, covering 3,000 acres within the Indianapolis city limits. It's ironic, as Mrs. Sutphin explained, that the golden eagle is not indigenous to Indiana, but local lore has it that one had been shot and killed 40 years ago about a quarter of a mile from the site where American Gold now stands.

The largest part of the struggle for acceptance is now behind Dan. In the past three years the number of commissions and sales have increased to the point where he finds it difficult to get away from his work for an occasional hunt or other recreational break. Other major commissions include Phoenix, which was produced for the DuPont Corporation's new facility in Wilmington, Delaware; Mountain Legacy, which welcomes millions of tourists each year to his mother's hometown of Estes Park, Colorado; Mountain Comrades, a personal favorite of Dan's of two mountain grizzlies commissioned by Remote Switch Systems, Inc. in Loveland; and Panzón, the fat bear from his latest zoo series.

In June of 1989, his election to the National Sculpture Society put him in the company of some of the greatest sculptors the United States has ever produced.

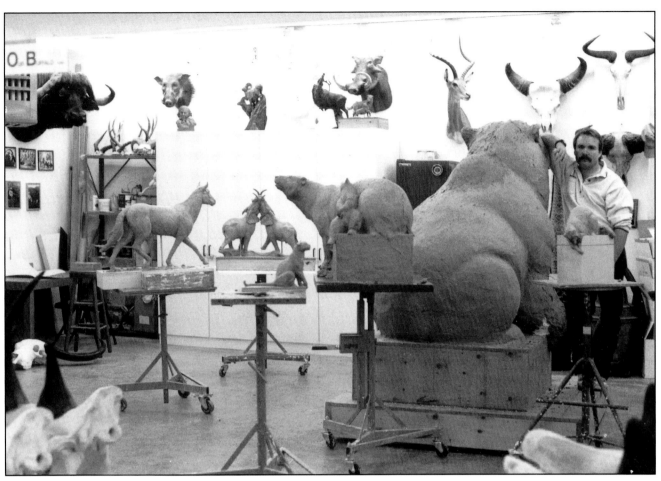

Studio Shot.

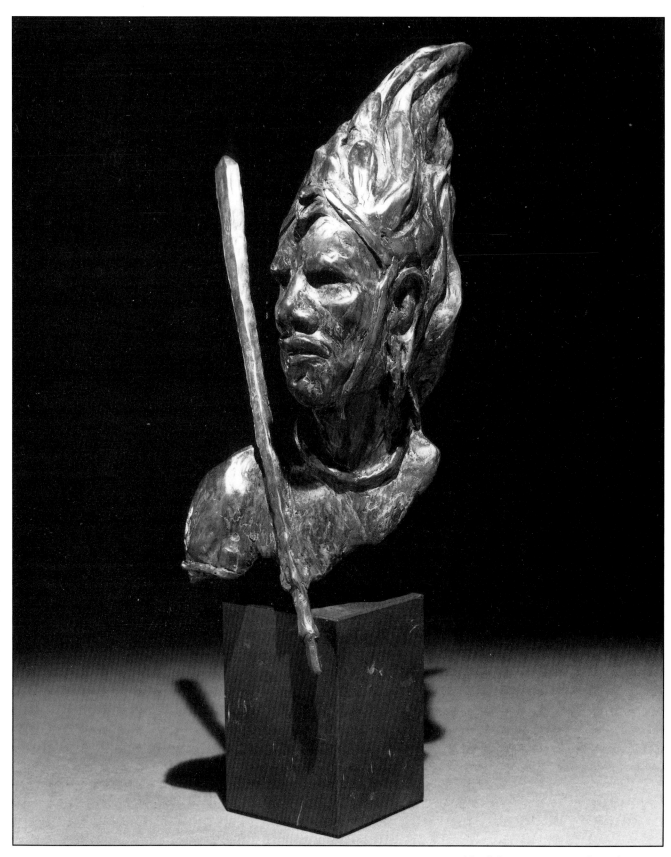

Nandi Spearman, 4" x 9¹/₂", Edition: 20

Chapter VII

Africa

If an admirer of Dan Ostermiller's work looks for the dominant influences on his subject matter and his themes, he has to take a long look at Dan's African experiences. From the time he was five years old, when his father returned from Africa, Dan knew that one day he too would hunt on that continent. He attacked his goal of hunting big game in Africa with the same zeal and determination as he had used in his quest to become a professional artist.

His little-boy dreams of Africa had plenty of fuel. Dan speaks lovingly of his father's gift of gab which was in full swing whenever he returned home from one of his extended hunting trips. His father spoke of the beauty of the landscapes, the varied tribes he encountered, and, of course, the wonderful animals he stalked in the bush. Dan took up his own research reading books such as William R. Leigh's *Frontiers of Enchantment* and Carl Akeley's *In Brightest Africa*. He clipped pictures from magazines and sketched pencil drawings from them.

"It's really funny, but it seems as though I was always more fascinated with African animals, although I had grown up around all of these North American animals. By the time I was 10 or 12 years old I knew as much about African animals as I did about North American animals."

In spite of everything he did to delve deeper into Africa, he knew that experience would be the only dependable teacher.

His first chance came in 1978. He was still working at Frontier and just beginning to sell some of his work. His fa-

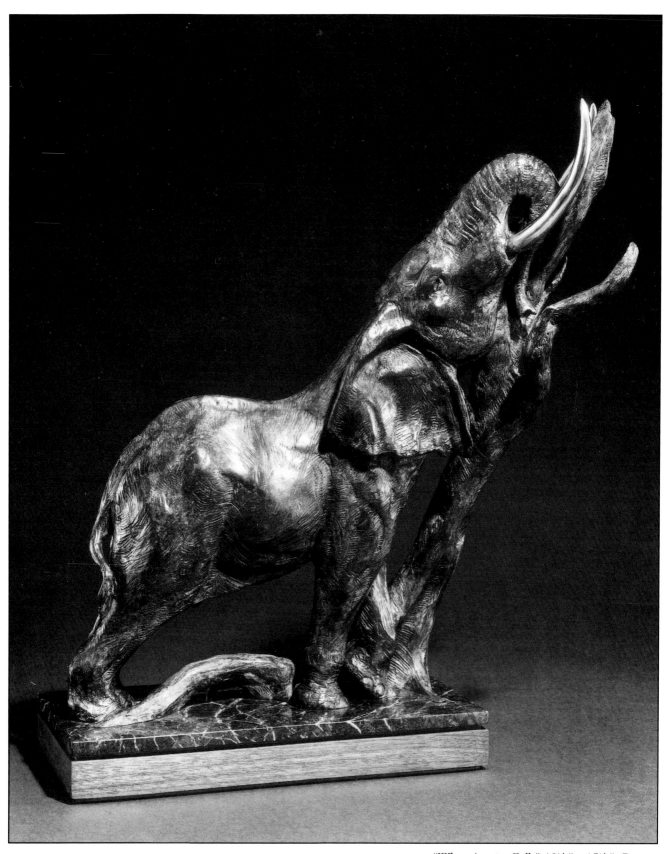

"When Acacias Fall," 18¹/₂" x 15¹/₂", Bronze

ther's personal experience of hunting in Africa and his long association with hunters and guides there provided easy decisions on contacts, locations, and logistics. After months of preparation, he packed up his dreams of the far-away land to measure them with reality.

"My first impression of Africa scared the hell out of me. We were landing and I looked out the window to see this armored troop carrier speeding alongside the jet down the runway. I thought, 'My God, we're going to get killed before we even get off the plane.'"

He knew it before he left, but he had elected to go to a country which was in the middle of a civil war. Rhodesia, as it was known then, had been involved in a "war of liberation" from white rule since 1969. The times and the military presence were to make some very interesting stories for the 22-year-old hunter.

Dan and his hunting party met with their guides, Geoff Broom and another young Rhodesian by the name of Gavin Rabinovitch. Gavin is a descendant of some of the earliest white settlers in the country and grew up among the native tribes in the bush. He has a degree in zoological sciences and is very knowledgeable about all aspects of the environment of his homeland. Finding a common ground in a love for hunting and the outdoors, the young man from the high plains of

In the pursuit of elephant, Dan now prefers his camera to his rifle. He captured the beauty and magnificence of this elephant during his 1982 trip to the Zambezi Valley.

Wyoming met a friend in the young man from the Rhodesian bush.

The party of seven hunters, two guides, and 10 blacks packed off into the bush in a finger of land wedged between Zambia and Botswana in western Rhodesia. The area is the aesthetically overwhelming site of Victoria Falls and the Wankie National Park. In Wankie, the safari went after elephant.

"Elephants are the most intriguing, exciting animal you'll ever see. There is an elegance in the animal I find beautiful. Some are very awesome for sheer beauty and magnificence—really dynamic animals that have adapted to their environment. The thing I like about elephants is their form and size.

"I remember seeing my first African elephant in the wild. That had to be one of the greatest thrills in my life. We were driving in a Land Rover down a dirt road and we came up on him. After seeing him in the wild, everything I thought of elephants from seeing movies and pictures of elephants was suddenly destroyed. He was a great graceful animal. When I saw that elephant, I knew I was in Africa."

Loving animals with a deep respect, as Dan has done for so many years, can lead to conflicting sentiments about killing them.

"I got my elephant on that trip, but I'd never do it again. He was with two *askari* bulls. Askari is Swahili for young warrior bulls that run with an old bull and provide him with protection and companionship until he dies. It was about 7:00 at night and getting dark. I shot him in some very dense jungle. I remember shooting and running after these elephants and Gavin grabbing me and stopping me from running any further. The askari were standing by the one I'd shot. It was dead still and here was this elephant running its trunk over the body of his friend. I could hear him breathing—smelling the body. Then he slowly turned and walked away. It was as if he was hanging his head and walking away knowing his buddy was dead. It certainly built my respect for the animal and the emotions it's capable of."

Africa may be a hunter's paradise, but Dan found that the wonderful animals he admired were better equipped to deal with the heat than he was.

"It's incredibly hot—about 120 degrees during the day. It might cool down to about 90 at night. It doesn't make for very comfortable sleeping, but when you've walked 25 miles in 100-degree heat, you're plenty tired.

"It seems as if we could never take enough water. We'd run out and Gavin would find a dry river bed and dig a hole and stick his head in and start drinking. Or we'd find where the elephants had done the same thing by stomping these huge holes in the river bed to get a drink.

"The lack of water could also be beneficial, from an artist's perspective. During the dry season, the animals bunch up around the remaining pools of water. When we'd find a rare watering hole, there would be an incredible assortment of animals around it."

Paradise it wasn't, but safari life lived up to its reputation for romance and glamour. They lived in tents and grass huts, piled their Land Rovers high with all of their supplies, and ventured off deeper into the bush.

Dan learned that the bush wasn't the only place that displayed an exotic wildness in Rhodesia—even the most civilized parts of the country were made a bit crazy by the civil war. After getting his elephant, Dan and the rest of the party ventured into Wankie to celebrate. The group was getting well-oiled in the Wankie Safari Club when the American noticed the townspeople carried some interesting additions to the evening apparel.

"They had machine guns—all of them! The women had these little Uzis and automatic pistols in their purses. We were getting drunk with a bunch of people armed to the teeth. A fight broke out in the bar and the guy's wife pulled out this automatic weapon and started waving it around. She pointed it at the guys beating on her husband and said, 'If you don't let him go, I'll shoot every son-of-a-bitch in this bar.' Scary scene."

Gavin also remembers someone else who got a little closer to a machine gun than he cared to that night.

"Danny got way too bloody drunk and stumbled out of the bar and fell asleep on the grass. He woke up early in the morning with the muzzle of a machine gun in his face. There was a curfew on and even though he was passed out, Danny was breaking it. They escorted him back to his room and sent him to bed," Gavin laughed.

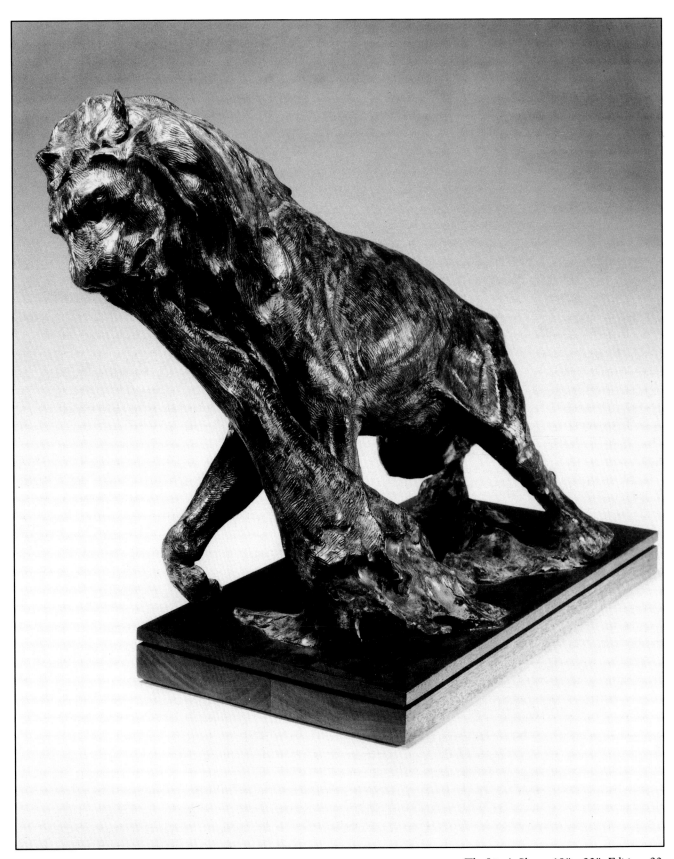

The Lion's Share, 18" x 20", Edition: 20

The group later headed farther west to Matetsi to hunt sable, kudu, and water buffalo. Some of the hunters then took Geoff Broom's plane over the Zambia border into the awe-inspiring Zambezi Valley to hunt cape buffalo.

"We flew into this grass strip to start our hunt for buffalo. We were getting ready to land and found that there were about a hundred buffalo on the landing strip," Dan said. "We had to chase them off by buzzing them so we could land."

Revolution and all, Africa surpassed his wildest dreams. The beauty of the Zambezi Valley left an impression he would not forget. There were deep rich colors spread across an unbelievable landscape that took on a new degree of beauty with each passing hour. Back home, the image would haunt him and he knew he had to see it again.

He got that chance in 1982. It was a much different trip from his first. The war was over and the country had adopted the name Zimbabwe; the trip was spent more in isolation driving to and from the Zambezi Valley, and the hunting party was considerably smaller. Only one person, Cheyenne attorney Mike McCall, accompanied Dan, Gavin, and Gavin's hired men.

Dan's role on this trip was more an artistic observer than hunter. He did more shooting with his camera than with a rifle. Like his father, he filled rolls of film with pictures of beautiful landscapes, studies of wild dramatic animals, and images of the people he met on their journey. He even went so far as to bring a piece of wax with him to sculpt while in the bush.

They loaded the two Land Rovers and Dan was off again with his friend Gavin to see the wild world of the bush.

"The Zambezi Valley is an incredible sight. It's huge. It goes through incredible changes throughout the day. I took photographs that you'd swear were taken with filters on the camera. The humidity and smoke from the grass fires mix to do some wonderful things with the light. I thought that if there was any place more beautiful than the Zambezi Valley, I had no idea where it would be. It's incredibly breathtaking to

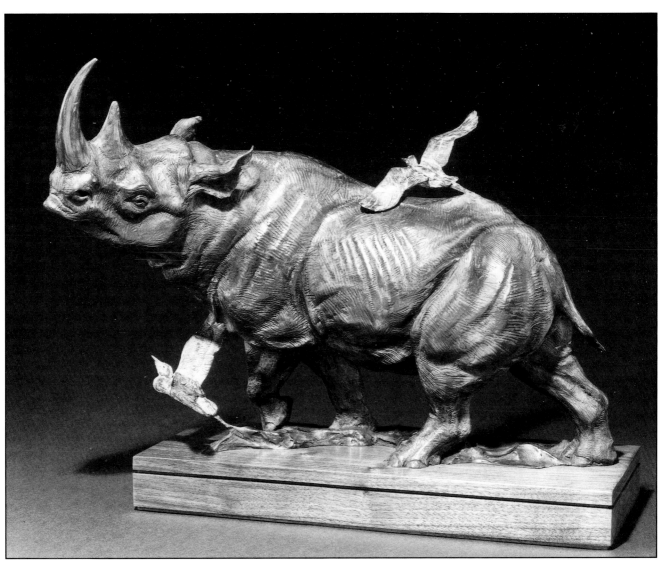

Unsteady Ground, 15¹/₂″ x 18¹/₂″, Edition: 20

stand on top of the escarpment and see the valley, the way it seems to roar in the sunsets. You can see the colors changing as some magnificent force blankets the sky with reds, purples and grays. I was thrilled to make it back to the valley on the second trip."

Gavin and Dan were like little boys with a huge playground all to themselves. They stalked animals for pictures to be added to Dan's extensive reference files and to capture images of the animals he so desperately wanted to sculpt again.

"Gavin showed me how to get good pictures of rhinoceros on that trip. We'd go out and antagonize them until they turned to chase us, then we'd run up a tree. Gavin told Mike and me to pick out a tree of our own to climb when the rhino came at us. I was snapping away with the camera when the rhino comes at us full blast. I turned to jump on a limb of the tree I had picked out and Mike had picked the same tree that I had and was already up in it. With this rhino breathing down my neck, I had to run down the row and climb another tree.

Poor eyesight makes the seemingly formidable rhino an easy target for hunters.

"I feel for those animals. They are very awesome looking creatures, but they're almost defenseless. They don't have natural enemies except man—maybe a lion will get a young one occasionally. They don't really charge you. They have such poor eyesight, they run up to you to see what you are and what you're doing. Killing one is no difficult task."

The two got creative when photographing cape buffalo by pretending to be another animal. One of them would stand in front, bent over, while the other did the same behind him and put his arms around the waist of the front man. They would walk together trying to look like a four-legged creature. The buffalo didn't seem to pay them any mind and Dan was able to get close-up pictures of the animals.

Another time, the hunting party was sitting beside a watering hole when an elephant came out of the growth to get a drink.

"This was where I got the idea for Zambezi Elephant," Dan said. "He came up to the pool side and posed every way you would ever want an elephant to pose for sculpture. I got everything. He wandered back and forth and I kept shooting pictures. I couldn't have asked for a more cooperative model."

While in the bush, Dan took out his wax and began experimenting on a sculpture of a baboon, which Gavin admired very much. They were having trouble with a new hired man who had made some exaggerated claims about his knowledge of the area and the animals that failed to prove true. He was lazy and greedy, and although he and Dan couldn't speak a word of the same language, Dan didn't care much for his type.

"Gavin took this wax baboon head and told this guy that the head was magic and if he didn't find us some animals soon, I'd put a curse on him and he would turn into a baboon. Gavin put the head on a stick and tied it to the Land Rover. Wherever this guy sat, Gavin kept the head staring straight at him. Scared the hell out of the guy. It was kind of cruel playing on his superstitions, but it kept the bastard in line."

"I think I did all right in what I got out of Africa," Dan said. "You talk to these guys who have gone 10 or 15 times and they can't tell you much about the environment or the animals they've hunted. As an artist, I came away with some very vivid impressions. It was important to me to experience the environment these animals live in. When you're working with expression in art as I do, you want to be able to put yourself in the work. It's difficult when you've read about it in books and seen it in pictures. But now, I can recall those smells and all of the sensations and it seems to put me back in the bush. I'll be sculpting then suddenly remember one impression that sets that animal off from another."

Some of his most dramatic pieces have grown out of his African experiences: The Escort, Zambezi Elephant, The Scratching Tree, Unsteady Ground, The Lion's Share, Secre-

tary Bird, Savannah Dispute, When Acacias Fall, Impala Ram, and Nandi Spearman, the only human figure Dan has cast in bronze.

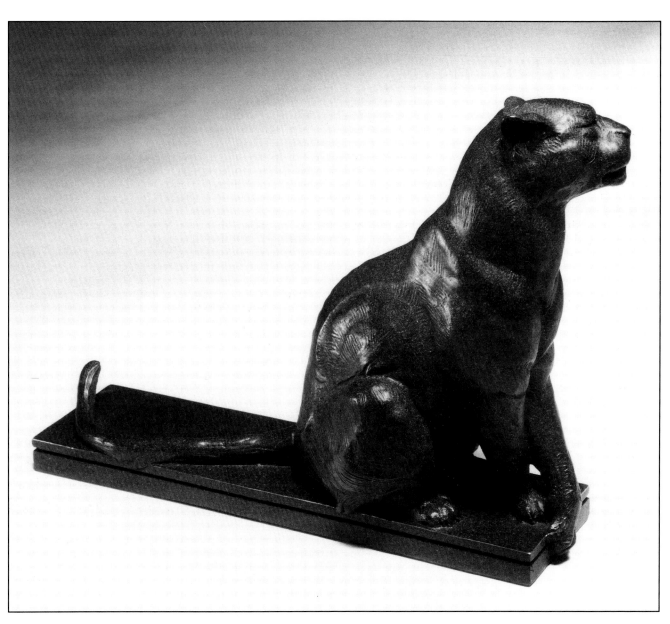

Cat Nap, 9" x 12", Edition: 20

Chapter VIII

His Work

Since the time Dan cast his first piece, Ram Skull, at the age of 21 while studying with Lloyd Woodbury, the path Dan has been on is the same one every artist must travel—a quest for a style that is his own; one that clearly says, "This is a Dan Ostermiller piece."

"Style is both a simultaneous process of building and tearing down," Dan said. "When first starting, an artist borrows elements from many different styles from many different artists. He looks at a sculpture, drawing, or painting and selects the effects he wants to achieve in his work. That makes for a very erratic composite of styles in the first pieces. That's your starting point. As an artist progresses and finishes a number of pieces, he can look back at that first piece and see the stylistic elements that have been eliminated and those that have been picked up. When the artist has eliminated the things that don't work for him, that's when his own style develops and begins to come out in his work.

"An artist should not expect to see a true style of his own until after five to ten years of experience. I don't think I had a style of my own until six years ago."

"Danny has found a style he is comfortable with for now. That's very important," George Lundeen said. "Once an artist finds a style and a subject, all he has to worry about is what he wants to say; not how he's going to say it. He's got the how out of the way."

The changes in Dan's subject matter as well as style are very apparent throughout his career. The subject of his first

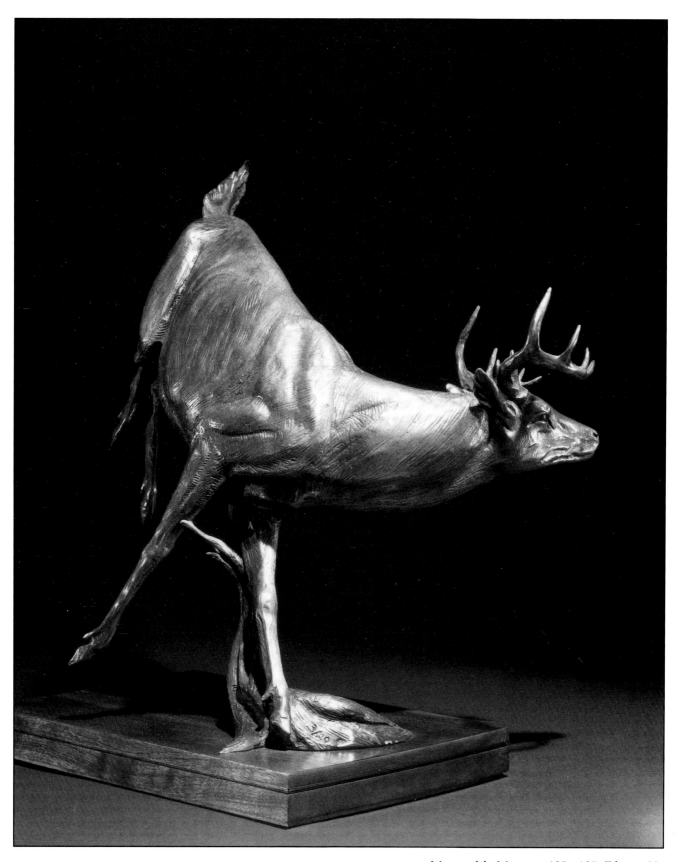

Master of the Mesquite, 18" x 13", Edition: 20

piece, Ram Skull, was a simple study of a skull he did primarily to learn the process of casting bronze. The ensuing pieces were of animals, but animals one would expect to see in his father's shop: taxidermy in bronze. They were sold primarily to hunters and outdoorsmen who were more interested in accurate depiction of the animals rather than artistic interpretation. After Dan made his crucial break with taxidermy, his business manager, his first wife, and his stagnant style in 1979, he began to take artistic chances. The piece Ibex is exemplary of this stage in which Dan often used sweeping lines and movement. From the base, the piece shoots up following a curving line that culminates at the head of the animal, which is thrusting itself up onto its hind legs.

"The biggest difference between sculpture and taxidermy is the freedom of sculpting compared to the restrictive nature of taxidermy. You can take taxidermy only so far using real skin and real horns. A leg can't be stretched and a body can't be elongated to achieve a desired effect. The artistic license can't be used much at all in taxidermy—everything has to be perfect and natural. Real character can't be built in like it can be in sculpture. The texture can't be created, it's defined beforehand. Taxidermy doesn't allow me to fatten up an animal to create a mood like I did with Panzón (the overfed grizzly in his 1989 zoo series). I couldn't distort him like I did in sculpture. Distortion is a wonderful thing in playing with design. Taxidermy is just a base, but a necessary one."

The word impressionism often comes up in conversations pertaining to Dan's work. The term may hold different meanings for different people, but each tries to express the striving of the artist to reduce the complexity of a design to add meaning: saying more by doing less.

Hollis Williford gave his own version of its use in Dan's work: "When a person changes from super complexity to super simplicity in his work, that person's facility and imagination grows. Simplicity is what everyone is looking for. That doesn't mean it's not involved. The Chinese learned about the simplistic view 500 to 1,000 years ago, and it's taken the

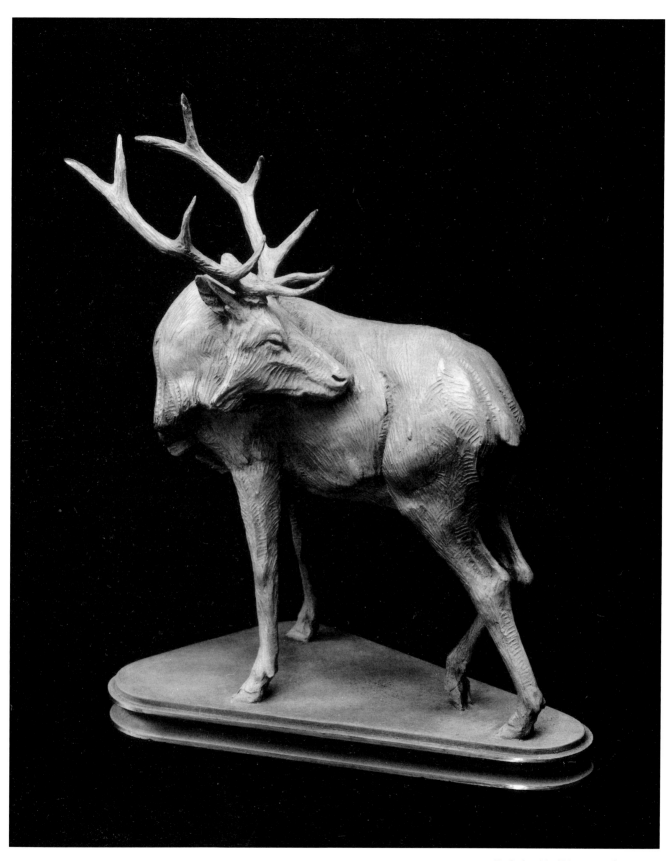

Prelude, 101/2" x 8", Edition: 20

West centuries to realize. It means that something needs to be more than representation of an object to be art."

Among his associates, buyers, and admirers, the feeling Dan gives to his subjects is probably the single most distinguishing feature of a Dan Ostermiller piece.

"He progressed rapidly," Fritz White said. "His early works had a lot more spirit and character than they did actual physical resemblance. Later, his work had both the spirit and the physical attributes of his subjects. Danny tries to get the feeling of the animal. Most people don't even try for the feeling, thinking an animal doesn't have a soul so why give it feeling? I'm not sure if he knew what he was doing, but if he would have sat down and analyzed his work I'm sure he would have recognized that he was shooting for character, as opposed to meat on the hoof."

George Lundeen offered his thoughts on the subject: "Danny's success in wildlife, unlike a lot of wildlife sculptors, is the action of the animal to get the point across. Many of his pieces show action, but a lot of them don't. I think he really tries to capture the essence of the animal just as it is. Like the deer standing (The Bonding), the buffalo (Buffalo) standing, and the eagle (American Gold) just kind of hanging there gliding. You really have to know an animal to get that effect in sculpture. Like the deer and her fawn—a person really has to study them for a long time to understand the attitude between the mother and the fawn without using some superficial human attributes to get the same feeling."

Dan does well at mixing his methods and themes. As Lundeen points out, Dan's mastery of the animal form itself allows him to present beauty and grace in what could be called static movement—movement presented in a stationary figure. Other pieces are centered around the movement. Motion is basically something getting from one place to another. In sculpture, the artist can take liberties in placing different parts of his subject in different phases of the action to produce the illusion of movement. Dan uses this theory in Bounding Mule Deer with two figures in an almost intertwin-

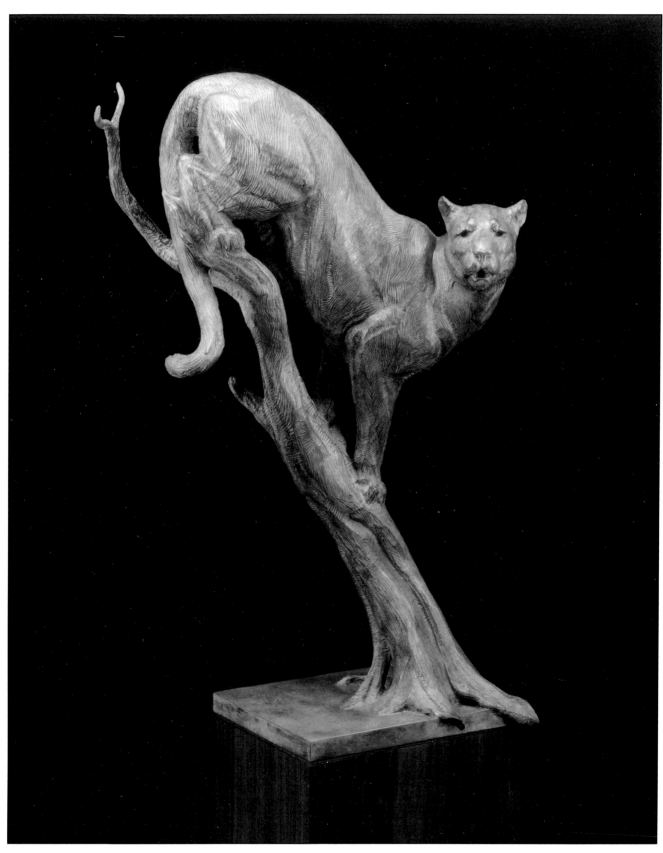

Vantage Point, 28" x 10", Edition: 20

ing motion. Both figures are engaged in fluid motion—one rising and the other appearing to have just landed and ready to rise again.

Steve Elliott, one of Dan's newer friends in the Loveland art community, has observed Dan and his work for only the last two years, but is able to trace his style back to his roots: "Seeing his earlier work and seeing what he is doing now, the earlier pieces didn't have the level of sophistication in the sense of form and of pattern on the surface. His early pieces weren't really amateurish, but over the years he's gained a real sense of form, design, and mass. He is a trained master of what makes a three-dimensional piece interesting from every vantage point. He is creating mass that is powerful. He knows anatomy so well from his formative years. He's seen so much animal structure he can quickly render animals he is familiar with and not have to pore over books to see what it is going to take. Dan can get an idea and create it so quickly. It's a tremendous skill. He has a real ability to take something to a finished form shortly after defining the idea."

Another element Dan uses effectively is working with the thematic pairing of animals. Early in his career, while searching for visual elements that would produce the effects he wanted to achieve, he discovered that pairing animals opens a wider arena for playing with mass, line, and the emotion of the animals as they interact. The visual tool is used in varying ways throughout his career with animals depicted in companionship, battle, affection, and pursuit. The Escort depicts two African elephants sharing a feeling of uneasiness as to what lies before them. His first monumental piece gives a glow of warmth and comfort shared between two rabbits in A Friend Indeed. A head-to-head struggle in Savannah Dispute presents a violent combining of rivals.

"Dan did a piece called Victory's Prize, two elk standing side by side with their heads raised," Betsy Ostermiller recalls. "I think it was really the first time he tried to get some emotion into the actual sculpture, or maybe it was the first time it really showed. From then on, he did a lot of pairs of animals.

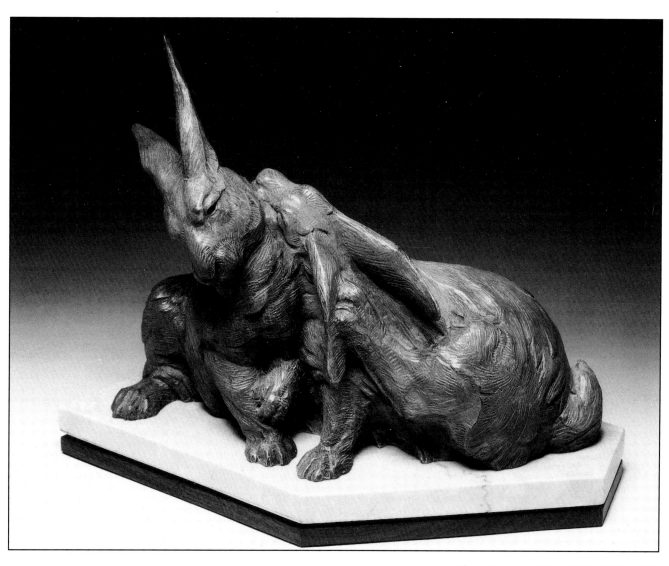

Close Quarters, 11″ x 13¹/₂″, Edition: 20

"Pairing animals presents the opportunity to have each figure play off of the other. That makes it easier to create emotion within a piece. The showing of emotion has always been one of Dan's strong points."

The changes in the thematic and emotional content of his work show a maturation of Dan as an artist. However, it is almost unanimously agreed upon by his associates that he really turned the artistic corner when he began producing monumental sculpture.

"The single thing that impressed me most about Dan," Hollis Williford said, "is he had the easiest time of anybody I know to turn from small exhibition pieces to monumental scale. That's where his taxidermy experience was a real advantage: he had been working with life-size pieces a number of years. Dan has a real gift for monumentally proportional pieces that a lot of other artists don't have. For most, it's not as easy a transition as it was for Dan.

"A single piece that marks a turning point for Dan is the monumental edition of the two rabbits, A Friend Indeed. As the first large-scale piece he did, I could tell immediately that overnight he made a transition from doing individual collector pieces to monumental art when he did those rabbits."

Dan also credits his background with greasing the wheels of transition: "I took the original study of A Friend Indeed, and I showed myself that I could bring up the character better in larger pieces. That's where a lot of sculptors have trouble and are afraid of doing larger pieces. I'm used to it. It's an advantage coming from a taxidermy background. I never really sat back and thought about why it was difficult. It is rather intimidating when you say, 'How do you get this thing big?' I just found that I was at home when sculpting an eye three inches long," Dan said.

"His big pieces are very successful," George Lundeen observed. "When artists do big pieces, they need to do them as well as they possibly can. I'm not saying that we always do, but in the smaller pieces, the artist can get away with a lot more imperfections because of their size. Just by their nature

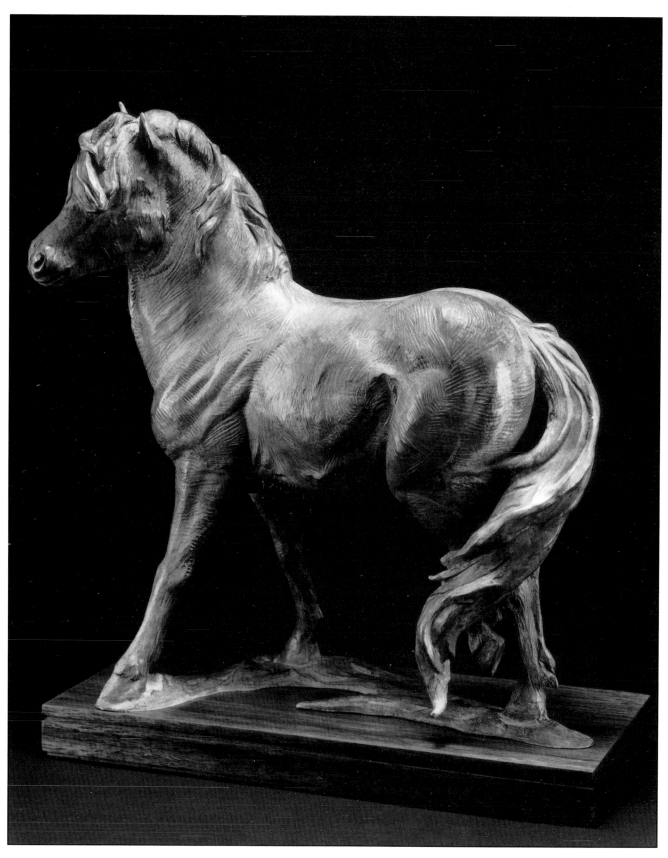

Shetland, 13" x 14", Edition: 20

as major pieces, I think a lot of extra thought and creativity goes into them. I think Danny is very successful at that."

"When his pieces are blown up into bigger proportions," Steve Elliott said, "instead of losing power, they gain power. If I had to pick one for my yard, it would have to be the Mountain Comrades. Panzón, the fat bear, is another one with great mass."

Nedra Matteucci sees American Gold as a piece that holds its appeal in both large and small editions: "First of all, it's a magnificent piece on its own, full of grandeur and beauty. In the monumental size, its wing span is all the more impressive. It is also appealing in the smaller size because it doesn't lose any of the majesty of the piece which often happens when a piece is brought down to a smaller size.

"Another thing that impresses me about American Gold," she said, "is it is anatomically correct. My husband, who is a falconer, has counted every feather and pronounces it perfect. It appeals to both those who are impressed with eagles, and those who know eagles."

It was an edition of Dan's monumental scale A Friend Indeed that served as an introduction to Loveland painter Clyde Aspevig. Aspevig said he was at an art show when he was attracted to a large pair of rabbits.

"The most important aspect of a piece of art is to be engaging. If a person walks by a piece and nothing happens, there's a good chance that the artist hasn't succeeded in saying what he was trying to convey," Aspevig said. "The first time I saw Danny's work, I walked over to it because it engaged my eye. First the size engaged me; then it was the subject matter; then it was his style. Dan's work has that emotional quality to it. People want to go up and look at it, touch it, and walk around it."

Dan believes he has turned another corner recently in his career with the creation of his zoo series. He has shifted his focus from wild animals to those whose characters have been transformed by their close association with man. So far, the zoo series includes Panzón, the overfed grizzly; High and Dry,

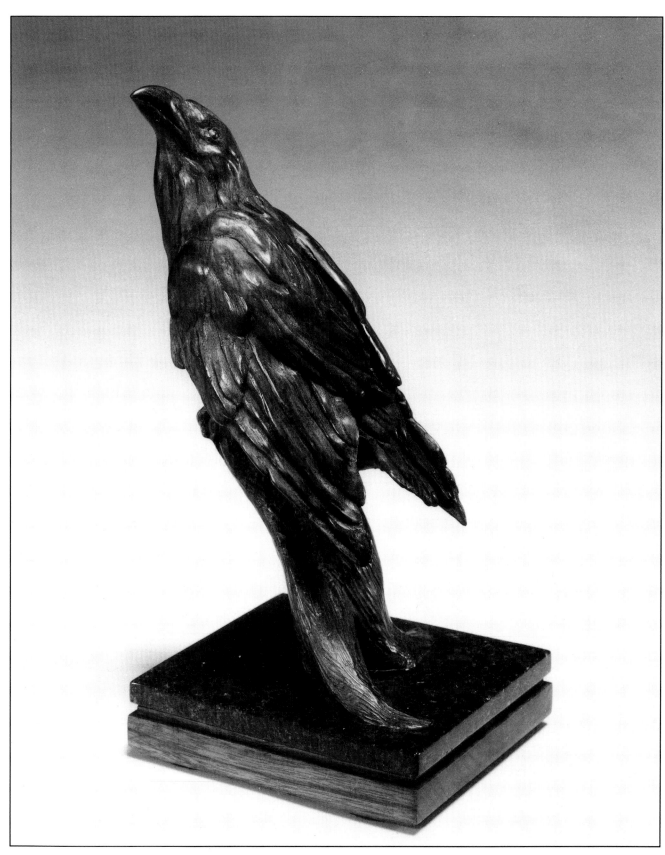

Nevermore, 10″ x 4¹/₂″, Edition: 20

an Asian elephant reaching off the base with an extended trunk; Cat Nap, a drowsy leopard; a pair of kangaroos (untitled); and a polar bear and her two cubs, The Ties That Bind.

"These pieces may seem humorous or patronizing in their tone, but I don't mean to approach them negatively at all," Dan said. "This series is a study of how animals in captivity show a different personality than their counterparts in the wild. It's not better or worse—just different. For example, Panzón is a fat grizzly bear that no longer has to hunt and search for food. He's overweight, he's just been fed, and he's still looking for someone—a human—to bring him more food. He now knows and has adapted to human factors such as time and routines. He exists and lives by elements that don't exist except in man's world. He is no longer like other bears in the wild that have to hunt and live by the laws of the wild."

A stylistic experiment Dan has used in the later stages of his career, which he uses effectively in this series, is extending parts of the animals off the base. This is most evident in High and Dry, where the elephant reaches completely off of the base with its trunk.

"I got the idea for High and Dry by watching an elephant at the Denver Zoo. The zoo keepers were cleaning the elephant's area and had drained the cement-lined moat where he got his water. He kept trying to reach down with his trunk to get a little patch of snow that was at the bottom. Every time he did, one of his back legs would come up."

In the untitled sculpture of the kangaroos, he uses the method again.

"Kangaroos always seem to be placed in low, flat, plains landscapes. The lines along the reclining kangaroo take the eye down to the tail which goes completely off of the base. This creates the impression of a vast empty space."

Another element he uses in the zoo series to reinforce the association between beast and man is placing the animals on geometrically structured bases. In contrast to a base that is made to fit a sculpture, the theme of the animals' reliance on

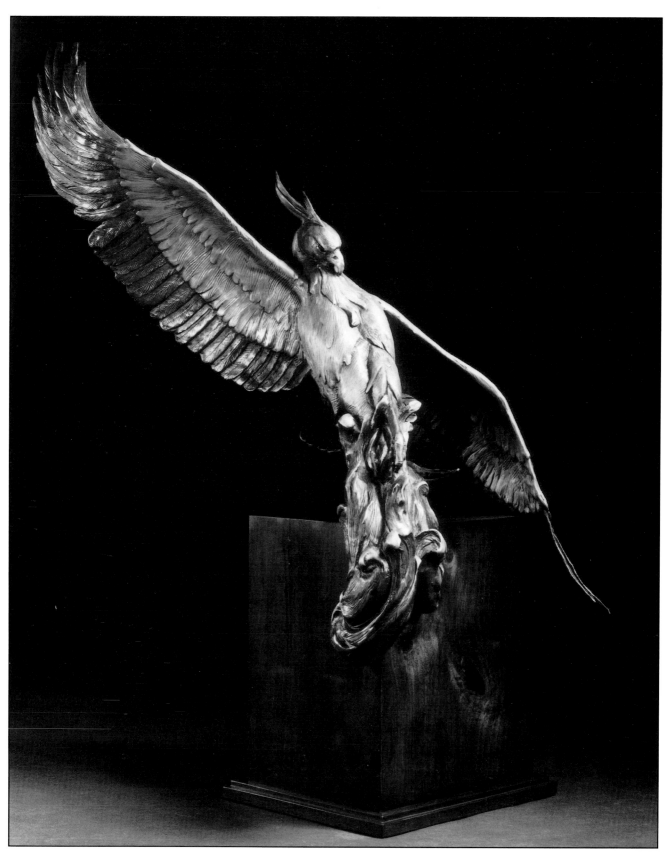

Regeneration I, 32" high, Edition: 20

man is continued by placing them on bases that fit man's neatly structured world.

"I've found something fascinating in these animals," Dan said. "Since I've started, I find myself being pulled more and more in that direction—and I thoroughly enjoy it."

Style, anatomy, feeling, and emotion are the brands of a Dan Ostermiller animal sculpture. He has worked hard to master the combination and to balance them over the past 15 years, and they have taken him to a level of relative success. Success, however, is a relative term.

When the word prodigy was used in reference to Dan, Hollis Williford had this to say about achieving success: "You know, I don't think he would like to even be considered that. Some artists do, but I don't think any artist is. The results you get are equal in proportion to the effort put forth. The more you produce, the more you grow—quality and quantity seem to go hand in hand. You don't get results and you don't become successful just by being praised as a prodigy or put on a pedestal. All you can call yourself in the business is a sculptor or painter or draftsman or whatever the word is for a technician in the medium you become involved in. That means, even when you become a master, that you are no less a student than when you first started. It will be after you are gone, and it will be someone else's job to make the statement whether you were a real—a success—or not."

Dan has resigned himself to that conclusion. He will produce art to the best of his capabilities. History will take care of the rest.

The amiable partnership of Roy Ostermiller (left) and Joe Nevins (right) built Frontier Taxidermy into one of the largest taxidermy shops in the world. The picture was taken by National Geographic photographer for a special edition on Cheyenne.

Clay sketch for The Ties That Bind

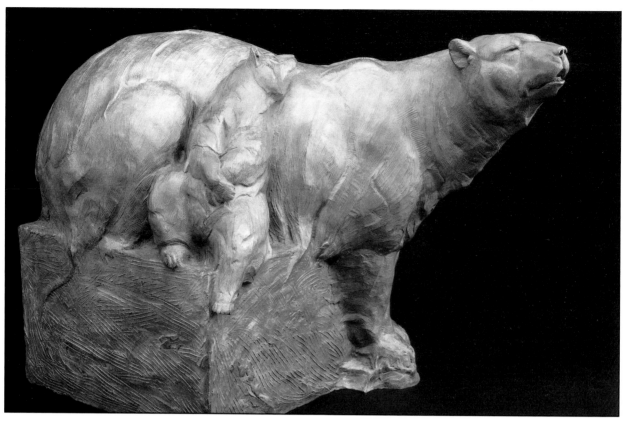

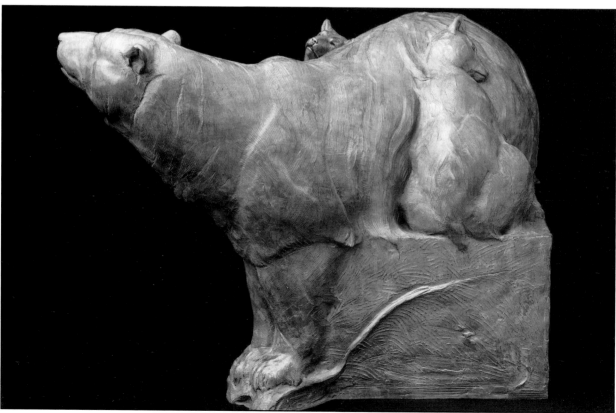

"The Ties That Bind", 22" x 33", Edition: 20

CHRONOLOGY

1956
July 2
Born in Cheyenne, Wyoming

1977
Cast first bronze sculpture: "Ram
 Skull"
Kerrville, Texas

1978
Commissions:
"Cougar Portrait"
Davey International
Houston, Texas

1980
Commissions:
"Bighorn Sheep"
First Wyoming Bank Corp.
Cheyenne, Wyoming

Shows and other events:
Betsy and Dan put together his
 first show
Frontier Taxidermy
Cheyenne, Wyoming

1981
Commissions:
"Big Red"
Orson Distributing
for Governor Ed Herschler
Cheyenne, Wyoming

Shows and other events:
Elected to the Society of Animal
 Artists, Inc.

Twenty First Annual Show of the
 Society of Animal Artists
New York, New York
1981 Exhibition of the Society of
 Animal Artists
Academy of Natural Science
Philadelphia, Pennsylvania

1982
Commissions:
"Bighorn Sheep"
Colorado State University
Fort Collins, Colorado

Shows and other events:
Society of Animal Artists Juried
 Exhibition and Sale
Denver Museum of Natural
 History
Denver, Colorado

An Exhibition In Fine Art
Lundeen Studio
Loveland, Colorado

Second Annual Governor's
 Invitational Western Art Show
 and Sale
Old West Museum
Cheyenne, Wyoming

1983
Commissions:
"Cape Buffalo"
Samuels Sheet Metal Co.
Youngstown, Ohio

Shows and other events:
1983 Exhibition and Sale of
 Wildlife Art
Benefit for The Nature
 Conservancy
De Colores Gallery
Denver, Colorado

Wildlife Art Exhibition
Golden, Colorado

Third Annual Governor's
 Invitational Art Show and Sale
Old West Museum
Cheyenne, Wyoming

Society of Animal Artists Juried

Exhibition and Sale
Washburn University
Topeka, Kansas

The American Artists Professional
 League 1983 Grand National
Salmagundi Club
New York, New York
Received Gold Medal of Honor
 for "Impala Ram"

Allied Artists of America, Inc.
 Annual Exhibition 70
National Artists Club
New York, New York

1984
Commissions:
"Chadwick Ram"
The Foundation for North
 American Wild Sheep
Cody, Wyoming

"Stone Sheep"
The Foundation for North
 American Wild Sheep
Gary Powell Memorial Award
Cody, Wyoming

Shows and other events:
Fourth Annual Governor's Invita-
 tional Western Art Show & Sale
Old West Museum
Cheyenne, Wyoming

First Annual Sculpture in the Park
Benson Sculpture Garden
Loveland, Colorado

Society of Animal Artists Exhibition
Cleveland Museum of Natural
 History
Cleveland, Ohio

1985
Commissions:
"A Friend Indeed" (monumental
 edition) commissioned and
 dedicated as the first sculpture
 purchased for the Benson
 Sculpture Garden by the Love-
 land High Plains Art Council
Loveland, Colorado

Installations of monumental
 sculpture:
"A Friend Indeed"
Benson Sculpture Garden
Loveland, Colorado

Shows and other events:
Artists of the West Exhibition
 and Sale
Pioneer Museum
Colorado Springs, Colorado

Major and Miniature Works of Art
The May Gallery
Jackson, Wyoming

Fifth Annual Governor's
 Invitational Western Art Show
 and Sale
Old West Museum
Cheyenne, Wyoming

Second Annual Sculpture in the Park
Benson Sculpture Garden
Loveland, Colorado

Wildlife, Watercolors, and Westerns
The May Gallery
Jackson, Wyoming

Art of the West
Bank Western
Denver, Colorado

Society of Animal Artists
Annual Juried Exhibition and Sale
Exhibition Hall, Crown Center
Kansas City, Missouri

Ten Day Invitational Art Show
Art of Denver
Denver, Colorado

1986
Commissions:
"Bonnie"
Lillian Akers
Loveland, Colorado

"Buffalo"
Trammell Crow Co.
Chicago, Illinois

Installation of monumental
 sculpture:
"A Friend Indeed"

Private Collection
Phoenix, Arizona

Shows and other events:
Second Annual Invitational
 Round Up Art Show
American Masters
El Paso, Texas

The Nature of the Beast
Southern Alleghenies Museum of
 Art
Loretto, Pennsylvania

Sixth Annual Governor's Western
 Art Show and Sale
Old West Museum
Cheyenne, Wyoming

Third Annual Sculpture in the Park
Benson Sculpture Garden
Loveland, Colorado

Thirteenth Annual Texas Cowboy
 Artists Association Awards
 Exhibition and Sale
The James M. Hany Gallery
Amarillo, Texas

1987
Commissions:
"Mountain Legacy"
Estes Park Urban Renewal Authority
Estes Park, Colorado

"Buffalo" by the Wyoming State
 Capitol
Cheyenne, Wyoming

Installation of monumental
 sculpture:
"A Friend Indeed"
Private collection
Lawrence, Kansas

"A Friend Indeed"
Private collection
Seattle, Washington

"Mountain Legacy"
Estes Park
Estes Park, Colorado

Shows and other events:

Fourth Annual Sculpture in the
 Park
Benson Sculpture Garden
Loveland, Colorado

National Art Exhibition of
 Alaskan Wildlife
Anchorage Audubon Society, Inc.
Anchorage, Alaska

Painting and Sculpture
The Twenty Seventh Annual
 Exhibition
Society of Animal Artists, Inc.
Philadelphia, Pennsylvania

Dedication of monumental com-
 mission "Mountain Legacy"
Estes Park, Colorado

Allied Artists of America, Inc.
Seventy Fourth Annual Exhibit
National Arts Club
New York, New York

Loveland City Council expresses
 appreciation for Dan's contribu-
 tion as a member of the Visual
 Arts Commission from Nov.
 1985 to Dec. 1987

1988
Commissions:
"A Friend Indeed" (medallion)
Loveland High Plains Arts
 Council
Loveland, Colorado

"Heart and Sole"
Lillian Akers
Loveland, Colorado

"American Gold"
Harold Kester
Loveland, Colorado

"Mountain Comrades"
Remote Switch Systems, Inc.
Loveland, Colorado

Installations of monumental
 sculpture:
"American Gold"
Horseshoe Bay Yacht Club
Horseshoe Bay, Texas

"American Gold"
Talon Corporation
Detroit, Michigan

"American Gold"
Civic Center
Loveland, Colorado

"Buffalo"
Wyoming State Capitol
Cheyenne, Wyoming

Shows and other events:
Dedication of monumental "Buffalo"
Wyoming State Capitol Building
Cheyenne, Wyoming

Texas Cowboy Artists Association
Fourteenth Annual Gold Awards
 Competition and Sale
Americana Museum
El Paso, Texas

Eighth Annual Governor's
 Invitational Western Art Show
 and Sale
Old West Museum
Cheyenne, Wyoming

Opening of Fenn Galleries
 sculpture garden
"American Gold" on display
Fenn Galleries
Santa Fe, New Mexico

Fifth Annual Sculpture in the Park
Benson Sculpture Garden
Loveland, Colorado

Dedication of "American Gold"
Loveland Civic Center
Loveland, Colorado

Society of Animal Artists Twenty-
 Eighth Annual Exhibition
Cumming Nature Center
Naples, New York

1989
Commissions:
"Regeneration"
DuPont Corporation
Wilmington, Delaware

"Woodrun Sunder"
Power Contracting

Arlington Heights, Illinois
"Panzón"
Private Collection
Santa Fe, New Mexico

"American Gold"
Private Collection
Nashville, Tennessee

Installations of monumental
 sculpture:
"American Gold"
Eagle Creek Park
Zionsville, Indiana

"Buffalo"
Fenn Galleries
Santa Fe, New Mexico

"A Friend Indeed"
Private Collection
Carmel, California

"A Friend Indeed"
Private Collection
Saratoga, California

"American Gold"
Private Collection
Jefferson City, Missouri

"Mountain Comrades"
Remote Switch Systems, Inc
Loveland, Colorado

"Regeneration"
DuPont Corporation
Wilmington, Delaware

"American Gold"
Private Collection
Nashville, Tennessee

Shows and other events:
March 17:
Dan elected to the membership of
 the National Sculpture Society
New York, New York

Third Anniversary Show
Nedra Matteucci Fine Arts
Santa Fe, New Mexico

Ninth Annual Governor's
 Invitational
Western Art Show and Sale
Old West Museum

Cheyenne, Wyoming
Sixth Annual Sculpture in the Park
Benson Sculpture Garden
Loveland, Colorado

1990
Commissions:
"American Gold"
The Morton H. Fleischer Museum
Phoenix, Arizona

"Golden Eagle"
Charles H. Phares Memorial
Estes Park Urban Renewal
 Authority
Estes Park, Colorado

Installations of monumental
 sculpture:
"American Gold"
The Morton H. Fleischer Museum
Phoenix, Arizona

"Panzón"
Fenn Galleries
Santa Fe, New Mexico

"Panzón"
Private Collection
Loveland, Colorado

"Panzón"
Private Collection
Kirkland, Washington

"Close Quarters"
Fenn Galleries
Santa Fe, New Mexico

"American Gold"
J.R.B. Development
Naples, Florida

"Mountain Comrades"
Fenn Galleries
Santa Fe, New Mexico

"Woodrun Sunder"
Power Contracting
Chicago, Illinois

"Mountain Comrades"
Private Collection
Seattle Washington

"Golden Eagle"
Charles H. Phares Memorial
Estes Park Urban Renewal
 Authority
Estes Park, Colorado

DATE DUE